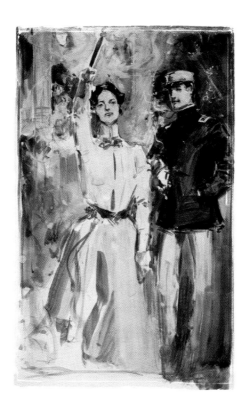

"A Splendid Little War"

THE SPANISH-AMERICAN WAR, 1898

────────── THE ARTISTS' PERSPECTIVE ──────────

◆

Annmary Brown Memorial, Brown University, RI
April 9 - June 19, 1998

Cantor Fitzgerald Gallery, Haverford College, Haverford, PA
September 25 - October 25, 1998

Henry Morrison Flagler Museum, Palm Beach, FL
January 5 - March 5, 1999

Heritage Plantation of Cape Cod, Sandwich, MA
May 8 - October 24, 1999

Published By:

Greenhill Books, London - Stackpole Books, Pennsylvania

Greenhill Books

"A Splendid Little War"
THE SPANISH-AMERICAN WAR, 1898
THE ARTISTS' PERSPECTIVE

First published 1998 by Greenhill Books, Lionel Leventhal Limited,
Park House, 1 Russell Gardens, London NW11 9NN
and
Stackpole Books, 5067 Ritter Road, Mechanicsburg, PA 17055, USA

Library of Congress
Catalog Card Number
97-32275

Printed by Newburyport Press, Inc. in the United States of America

◆

◆

◆

◆

We would like to acknowledge the help and assistance of the following persons:

James W. Cheevers, Associate Director and Senior Curator,
United States Naval Academy Museum

Susan Conway,
Susan Conway Gallery at Glackens House, Washington, D.C.

David Meschutt, Formerly Curator of Art,
West Point Museum, United States Military Academy

Jorge H. Santis, Curator of Collections,
Museum of Art, Fort Lauderdale

Holly Longulski,
Howard Chandler Christy's daughter

Helen F. Copley,
Dallas, Texas

Peter Simmons,
Museum of the City of New York

Terrence Brown, Director, Society of Illustrators
New York

Suzanne Folds McCullagh, Curator of Earlier Prints & Drawings
Art Institute of Chicago

Inspiration, Acquisition, and Research Support was provided by:
Walt & Roger Reed,
Illustration House, Inc., New York City

Acquisition of English Artwork and Research Support was provided by:
Jim Clancey, Richard Kossow, and Glenn Mitchell
Maggs Ltd, London

Conservation and Framing of artwork in the Jean S. &
Frederic A. Sharf Collection was organized and executed by the following:
Susan Duhl, George Eberhardt, Mark Wallison
and Sande Webster, all of Philadelphia

Valuable research assistance was provided by:
William T. LaMoy, Director
James Duncan Phillips Library, Peabody Essex Museum
Salem, Massachusetts

Transcribing of Macpherson's Reports was organized by:
Ms. Nancy Tenbroeck
Salem, Massachusetts

Catalogue Designed by:
Dianne Tine
Newburyport Press, Inc. - Newbury, Massachusetts

◆

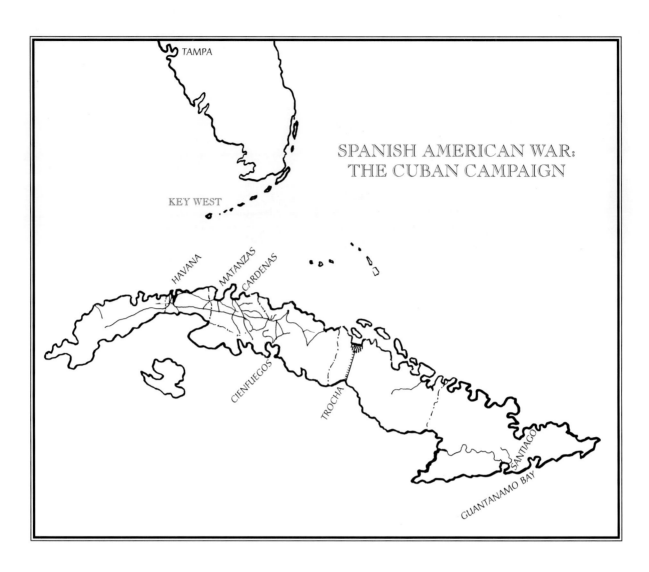

SPANISH AMERICAN WAR:
THE CUBAN CAMPAIGN

TAMPA

KEY WEST

HAVANA

MATANZAS

CARDENAS

CIENFUEGOS

TROCHA

SANTIAGO

GUANTANAMO BAY

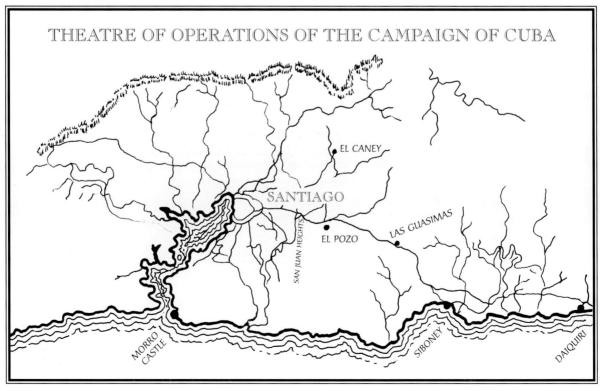

THEATRE OF OPERATIONS OF THE CAMPAIGN OF CUBA

EL CANEY

SANTIAGO

SAN JUAN HEIGHTS

EL POZO

LAS GUASIMAS

MORRO CASTLE

SIBONEY

DAIQUIRI

Foreword

by Frederic A. Sharf

◆

I was already interested in the various "imperialist" wars which took place in the late 19th and early 20th centuries; and had already put together an important collection of Japanese woodblock prints depicting the Sino-Japan and the Russo-Japan Wars, which was being organized for a national touring exhibition; when in August, 1989 I visited the New York City art dealers Walt and Roger Reed. I was seeking original works of art depicting the Sino-Japan and the Russo-Japan Wars. I was shown a group of watercolors of the Spanish-American War by Walter Granville- Smith...and I fell in love!

Having successfully introduced me to an event in American history which remained clouded in obscurity, the Reeds proceeded to track down additional artwork, and within six months I found myself with a real "collection"; and a compulsion to understand the events which my works of art depicted.

I assembled my own library of contemporary source material, and spent many evenings immersed in research. My research addiction logically led me to seek the assistance of one of the world's leading military archives: the Anne S. K. Brown Military Collection, located at the John Hay Library of Brown University in Providence, Rhode Island.

Fortunately, the Curator of this collection, Peter Harrington, shared my enthusiasm for the Spanish-American War, and my commitment to accurate research in contemporary sources; we became friends and colleagues. The idea to develop an anniversary exhibition which would deal with the artwork of this war was entirely Peter's!

We embarked in the spring of 1990 on the road which has led to the current exhibition and catalogue. We have digested thousands of pages of contemporary newspaper accounts; as well as the numerous published accounts by eye-witnesses. We have traveled to London to look at the war through the eyes of contemporary European observers in the pages of *The Daily Graphic* and *The Illustrated London News*.

We discovered that there was an extensive body of artwork produced to document this war, but that little of this material survived. Eight years of collecting and inquiry have thus yielded a modest, but important grouping...which we are pleased to bring to the public's attention.

◆

Chronology of the Spanish-American War

by Peter Harrington

◆

1898

February 15: *Destruction of the U.S.S. "Maine" in Havana Harbor*

April 22: *Atlantic Squadron departs Key West to blockade coast of Cuba*

April 25: *Official declaration of war, effective as of April 21st*

April 27: *Bombardment of Matanzas*

April 29: *Bombardment of Cabañas*

May 1: *Dewey's victory at the Battle of Manila Bay*

May 12: *Atlantic Squadron bombards San Juan, Porto Rico*

May 18: *Flying Squadron ordered from Key West to Cienfuegos*

May 28: *Flying Squadron at Santiago to establish blockade*

June 3: *"Merrimac" sunk at entrance to Santiago Harbor*

June 6: *Army begins boarding transports at Tampa*

June 10: *Marines establish land base at Guantanamo*

June 14: *Army sails from Tampa*

June 22: *Landings at Daiquiri. Advance on Siboney*

June 24: *Skirmish at Las Guasimas*

July 1: *Battles at El Pozo, Kettle Hill, El Caney, and San Juan Hill*

July 3: *Naval battle in Santiago Bay*

July 4: *Siege of Santiago commenced*

July 17: *Spanish surrender to General Shafter*

July 25: *Landings at Guanica, Porto Rico;*
arrival of General Merritt's force in the Philippines

July 27: *Ponce, Porto Rico, taken*

August 12: *Armistice agreement between Spain and the United States*

August 13: *Battle of Manila*

August 14: *Spanish army in the Philippines capitulates*

1899

February 4: *Philippine Insurrection begins - ends July 4, 1902*

◆

1898: The Artists' Perspective

by Peter Harrington

◆

From the hindsight of a century, it is easy to be critical of the jingoistic attitude of American society in 1898. Modern experience tells us that colonial adventures and arms races are things of the past never to be repeated again. Yet we need to look at the Spanish-American War from the perspective of the society that pursued the war effort; in a sense we need to think as Americans thought a century ago to gain a better understanding of the war. The pictures of that conflict may help provide a small window into that consciousness.

The United States had not fought a major war in over 30 years. She had not opposed a foreign nation on the battlefield in fifty years. While her western states had waged small campaigns against native Americans, few in the great industrial cities along the eastern seaboard or bordering the Great Lakes showed much enthusiasm. For them, the continued growth of modern industry was their priority and their goal was to make America a world power. Across the Atlantic, the countries of Europe were scrambling to secure colonies while the larger nations were locked in a major race to build massive navies which could project their country's power, prestige, and image abroad. Americans wanted this too. If colonies and navies were the conditions for entering the great power club, then America must have them.

When the Spanish-American conflict erupted in the spring of 1898, those world powers rushed their observers to the seat of war to report on the effectiveness of modern weapons in battle. There had been no major war between industrial nations since 1870. More significantly, there had been no significant naval battle since the Austrian and Italian fleets faced off against each other at Lissa in the Adriatic in 1866, so the naval planners were eager to see how modern fleets fared in battle. In other words, wars were good testing grounds to view new weaponry and the war of 1898 provided a "welcome" scenario.

And there is one final ingredient to consider: wars sell papers. "The Spanish-American War is a type apart. It is a newspaper-made war, the first, though probably not the last." So went the editorial which appeared in the *Saturday Evening Post* on June 7, 1898, entitled "The Danger Side of War" in which the *Post* stated that the New York and Chicago 'yellow' press had hurried the American government into war even before the army and navy departments were ready. It claimed that the plans of the two departments were published in the press before they were operative and that the American fleet was accompanied by newspaper despatch boats reporting every movement. Indeed, had it not been for the pressure placed on the government in Washington by the press to come to the aid of Cuba, war might have been averted in the first place. A century later, the Spanish-American War is synonymous with the machinations of the press barons, the most notable being William Randolph Hearst of the New York *Journal*.

While the crisis came to a head with the sinking of the U.S.S. "Maine" in Havana Harbor on February 15, 1898, it had been brewing for over two decades. Almost exactly twenty years earlier on February 10, 1878, Cuban *insurrectos* concluded a ten year war with Spain with a peace treaty which guaranteed Cubans a number of freedoms. Thereafter, they enjoyed a period of peace and prosperity but this gradually began to erode as the corrupt Spanish administrators reinforced their old repressive measures. In February 1895, Cubans decided once and for all to rid themselves of the colonial regime and began a campaign of violence to win independence, with the backing of the United States which urged on the revolutionaries with money and weapons. This crusade appealed to the imagination of many in America, particularly Hearst who sent his top journalist, Richard Harding Davis, and the artist, Frederic Remington, to cover the crisis. The violence erupted into a full scale revolution and the American press were on hand to cover it. While Remington was sending back sketches, other drawings and photographs were obtained from Cuban participants, and the re-drawn images appeared in papers such as *Harper's Weekly*.

The papers began to dwell on a number of ugly incidents involving American citizens in Cuba although the details were exaggerated in many cases, and one of Remington's drawings had contributed towards this. Nonetheless, it had the desired effect of creating a strong anti-Spanish feeling in the States. Order was breaking down in Havana and Consul Fitzhugh Lee's request for help brought the "Maine" from Key West. The explosion of the ship was the precipitating moment in the growing rift between the United States and Spain over the latter's harsh regime in Cuba. The declaration of war between the two on April 25, 1898, came as no surprise to the majority of Americans and provided an element of satisfaction to the press barons.

Even before war was declared, the army had begun moving troops from Chickamauga, Tennessee to Tampa, Florida, which would be the primary base for the invasion force and headquarters for the army during the campaign. A similar force of artists, photographers and correspondents headed to Tampa, many of them recently hired to cover the pending war. Others journeyed to Key West which was to be the center of operations for the navy, and Walter Russell, an artist for *Collier's* and *Century Magazine* described "an army of correspondents and artists...representing newspapers and magazines all over the globe" descending on the town, where the New York *World* estimated there were somewhere in the order of 150 newspaper correspondents gathered. Around the world, newspapers scrambled to get their 'specials' in place to cover the war. Artists were sought after to create images of the war which the photographers were unable to. While the camera could snap a posed shot of troops in camp or marching, any attempt at capturing photographs of battle was not practical. Some 'movie' cameras were on site to record the troops boarding the ships, but most of the moving images of battles were faked. It was up to the illustrators to create the atmosphere of the expected fighting. A number of artists were taken on also for their journalistic skills and were expected to file reports to accompany their sketches. This was particularly true for the British papers. Papers tried to outdo each other and each proudly proclaimed that they had the scoop as the following statements suggest:

Leslie's Weekly, Saturday, April 21 -
"As it was first in the field with an expedition to Alaska, so Leslie's Weekly is first in the field of possible war operations. Our staff of artists assembled at Key West, with a fast yacht of the highest speed at their service, is in charge of Mr. F. C. Schell, the well-known illustrator of marine incidents."

Leslie's Weekly, Saturday, May 19 -
"Leslie's Weekly has an artist, a photographer, and a correspondent on every battle-ship and every battle-field. It is presenting the best pictorial history of the war that can be given...We want to stir the patriotism of the American people to the highest pitch..."

Harper's Weekly, Saturday, April 23 -
"In the event of war with Spain, Harper's Weekly will be represented at the front by a brilliant staff of artists and correspondents. Rufus F. Zogbaum, Frederic Remington, Carlton T. Chapman, W. A. Rogers, and others have been engaged to follow the movements of the Navy and the Forces in the field. No other illustrated periodical will possess equal facilities for accurately and artistically portraying the maneuvers and battles in which our Navy and Army may engage."

Truth, March 30 -
"No periodical at any price can offer pictures that will vie with the beautiful Naval pictures that will appear in TRUTH during the next few weeks. We don't want war, but if war comes TRUTH's readers will get the best war pictures obtainable, and in colors too."

McClure's Magazine June -
"McClure's Magazine has representatives, contributors, artists, and photographers with every branch of the army and navy and at every scene of probable action...the magazine is represented at Washington, on the Flying Squadron, on Admiral Sampson's fleet, at Hong Kong and Manila, at Tampa, Mobile, and in Cuba; and through its London office is able to secure the most apt and important material from foreign sources."

McClure's had hired William Glackens to illustrate the war at the front. The manager of the magazine's art department wrote to Glackens asking him "to go to Cuba with the American troops" and send "illustrations telling the story of the departure, voyage and arrival and subsequent work and fights of the U. S. troops in Cuba." He arrived in Tampa early in May where he was instructed to locate Stephen Bonsal who had also been taken on by the magazine. The letter went on, "whatever Mr. Bonsal and yourself decide, then do, but keep in mind what we want from you is the story of the U. S. troops going to and in Cuba...Of course, I forgot to tell you something which is so naturally implied that with all the bustle and hurry of your departure it was forgotten - about your being our exclusive correspondent and all the stuff you make on that trip is ours. Send it along in any shape it may be - we will use it either in the magazine or in some way." Arrangements had been made for the artist to travel whenever he needed on one of the New York *World*'s boats in return for "some of your drawings. Whenever you have any rough things done quickly send them along and I will pass them along to the *World*."[1] In Tampa he set to work sketching the army as it gathered for the campaign.

While the nation watched and waited for some news from Tampa, Key West or Cuba, the first news of a victory came from the Philippines. On May 1, Admiral Dewey defeated a Spanish fleet in Manila Bay. There was an overwhelming sense of success and pride over the navy's achievement, and the papers provided their readers with accounts and illustrations. But their teams of journalists were still down in Florida waiting for the main action, their frustration over the inactivity of the invasion force often bubbling over into their newspaper columns. Several returned to New York to await some movement. General Shafter finally received orders to move his 25,000 troops to Cuba commencing May 26 but embarkation did not begin until June 7, and even then most troops did not commence boarding until the 8th. By now, the artists and photographers had visited and re-visited the encampments of the troops around the city and beyond and the reading public was very familiar with the scenes. Word finally came that the gentlemen of the press could board transports at Port Tampa nine miles from Tampa. Glackens hastily made sketches of the troops in the marshaling yards boarding transports to accompany the reports written by Bonsal, and it was now his turn to board the transport "Vigilancia". Howard Chandler Christy of *Leslie's* also covered the embarkation and made this comment: "So dense were the bodies of troops on shore that it was almost impossible to move about, and regiment after regiment had to stack arms and await their opportunity to move." It was a chaotic situation for the pier could only accommodate 9 ships at a time, and a single railroad track brought the troops to the

Howard Chandler Christy in campaign clothes
from a photograph in *Leslie's Weekly*, 1898

docks. Regiments arrived not knowing what ship they were assigned to. The men had to jostle between mules, guns and wagons to reach the gangplank. As for the press corps, the excitement on being allowed to depart was soon tempered as the transports were ordered to stay off Port Tampa for a week.

In the meantime, Admiral Sampson's fleet had sailed out of Key West to blockade Cuba on Friday, April 22, and the press had a number of artists either on board naval ships or sailing along on the 15 dispatch boats rented or owned by the newspapers. Walter Russell, representing *Collier's* and *Century Magazine*, was aboard the New York *Herald* tug, "Sommers N. Smith" armed with a telephoto scope in order to obtain close-up photographs with which to compose his drawings. Other artists included Henry Reuterdahl representing *Truth* but traveling also on the *Herald's* boat, and *Harper's* artists, Rufus Zogbaum, Frederic Remington and Carlton Chapman. The latter was on the New York *Sun's* boat, the "Kanapaha" when the first naval action of the war occurred, the capture of the Spanish merchant ship, "Buena Ventura" by the U.S. gunboat "Nashville" on the 22nd. His colleague, Zogbaum was allowed to travel on Admiral Sampson's flagship, the "New York", and his first experience of the war was the bombardment of shore batteries at Matanzas on April 27. He described this event:

"For several minutes the fire continues, steadily maintained by one ship or the other, replied to only at intervals by the Spaniards. Some of the hostile shots fall near, but not a vessel is struck; and the object of our attack - the annoyance of the enemy in the construction of new fortifications - having been accomplished, our ships slowly with-draw, followed by one last defiant shot from the hostile lines."[2]

Russell and Reuterdahl also witnessed the bombardment, from the deck of the "Sommers N. Smith", which returned to Key West arriving there at 1:00 am on April 28, so that the correspondents could telegraph their reports and post their sketches and photographs. Remington, for his part, had been aboard the U.S.S. "Iowa", but seeing very little action asked to be transferred to a torpedo boat to take him to the "New York", but arrived too late to observe the action off Matanzas which annoyed him. As his report in *Harper's Weekly* on May 14 stated, "Mr. Zogbaum and Richard Harding Davis had seen it all, note-book in hand. I was still with jealousy; but it takes more than one fight to make a war - so here is hoping."

Remington returned to the mainland to cover the mobilization of the expeditionary force at Tampa and after a long wait embarked with the troops in June, but the plans of the press corps to cover the landings of the American troops were thwarted when General Shafter issued an order stating that any civilians not directly involved with the operation would have to remain on board the transports until the landings were accomplished. The various artists on the troop ships contented themselves with making sketches from a distance, of the bombardment of Daiquiri and the troops disembarking. During the three days it took to get the force ashore, some of the journalists on the press boats did manage to land on Cuban soil but with little idea about what to do next. Eventually all the correspondents were allowed to go ashore and by the June 24 most of them had set up camp or attached themselves to units of the army which were beginning to move off towards the town of Siboney four miles away.

Christy landed at Siboney on the 24th and recalled that no sooner had he reached shore with the Second Infantry Regiment, than they were rushed into action at Las Guasimas: "Along about 8:30 o'clock we heard a queer rumbling noise over the hill, and an order came for the regiment to go at once to the relief of the rough riders and First and Tenth Cavalry, regulars, who had met the Spaniards in a fierce battle."

The artist was very moved by his first sight of wounded soldiers streaming back, some of them friends he had made on the voyage down. Later he visited the little hospital which had been set up before walking over the field of Guasimas to see for himself the scene of the carnage. "Empty Mauser shells were so thick that it was impossible to walk here without stepping on them." Towards the end of June the American forces moved off towards Santiago but there was a lot of confusion as the troops, artillery, and pack-trains crammed into the narrow valley through which the track to Santiago ran.

Besides the army and the American press corps in tow, there were numerous foreign military attachés and correspondents representing European newspapers, particularly British. The war held a fascination for Britons and they were particularly keen to follow the naval episodes. Most of the major London papers had dispatched teams to cover the war and the illustrated press was similarly represented. Representing *The Daily Graphic* and *The Graphic* was Douglas Macpherson, a twenty-six year old artist-correspondent covering his first war. In contrast was the veteran pictorial journalist, Henry Charles Seppings Wright of the *Illustrated London News*, and the New York *World*, who had seen war first-hand in Africa and Greece. Wright had in fact already landed on Cuban soil in early May with Sylvester Scovel of the New York *World* to locate General Gomez, and he wrote:

"On May 1 I started with Scovel (sic), of the New York World for the blockading squadron off Havana. We embarked on the good tug Triton, belonging to the New York World…sighted the Blockading Squadron, or rather the "New York"…invited aboard…Admiral Sampson sent for me, and kindly allowed me to make a small pencil sketch of him in his cabin…Replying to my request to be allowed to take a trip with him or some other ship, he politely refused, stating that the orders of the War Department were peremptory on the subject of correspondents - indeed absolutely prohibiting their presence on vessels of the fleet, the only exception being made in favour of three representatives of the Associated Press of America. This seems quite fair, as the applications have been so numerous that he could have filled every ship with them. My friend Scovel urged that I was an Englishmen, and represented a big English journal; but it was no use. As Scovel was going to land in Cuba to take a despatch to Gomez, I requested and obtained permission to go."[3]

Having landed on Cuba, the two journalists had to hide for several days to avoid capture and they got lost but were able to forward a dispatch to the Cuban general informing him that war had been declared, before making their escape by stealing a fishing boat which they sailed until reaching the fleet. Later when the press corps landed in late June, Seppings Wright came ashore and covered the campaign to its conclusion sending back numerous rough sketches by mail to London where they were "drawn-up" by staff artists for publication in the Saturday issues. Approximately four weeks elapsed between the date Wright made the sketches until the date the re-drawn pictures appeared in the weekly; similarly Macpherson was subject to the same time lapse although many of his sketches appeared in their 'raw' state in *The Daily Graphic*. Other sketches by him were re-drawn by artists at *The Graphic's* offices in the Strand for publication in the weekly. The American artists did not have the same time

constraint although it still could take upwards of three weeks or more before pictures were published. For instance, *Harper's Weekly* published pictures on July 16 of the landing at Daiquiri drawn by Carlton Chapman on June 23. *Leslie's* first drawings of the battles of July 1 appeared in its issue of July 21.

The artists initially made rough sketches in pencil of the scenes they witnessed, and in the evenings, made more finished ink and wash drawings suitable for publication in the ten cent papers such as *Collier's Weekly* which commanded the largest circulation of any of the illustrated weeklies, over 150,000 copies. These pictures were then sent back to Florida on the various despatch boats and mailed to the newspaper offices in New York. In most cases, the drawings were photographed and made into metal half-tone blocks created by using a photographic and chemical procedure to divide all areas of gray into tiny raised dots. These spots were equally spaced but varied in depth of value for different parts of the drawing. For light portions, the dots were small but larger for dark portions, giving an approximation of the tone from the original picture in the printed version.[4] As for the two cent daily papers published in New York and elsewhere, their artists sent inked line drawings back home which were reproduced as they were. The New York *Herald's* artist, W. O. Wilson, and his counterpart for the New York *Journal*, George A. Coffin, posted many outline sketches which graced the front covers of their respective papers as well as regional papers which purchased reproduction rights.

By June 30, the army was in place poised to attack the fortified positions around Santiago, in particular the defenses at Caney and San Juan Heights. Christy described the Second Regiment being ordered to break camp on the 30th and move towards San Juan in preparation for the attack the next morning. He remarked that everything was soaking wet and that the mud was a foot deep in places:

"Early that morning we heard the deep boom of Capron's guns, over toward Caney. I went forward to the little hill at El Poso where Grimes' Battery (four guns) was placed, and from this point a view of both battles could be had...Now the regiments near our station at El Poso received orders to push forward down the road toward San Juan, and what a splendid sight it was! The officers shouting commands; the flash of steel in the sunlight; the sound of trumpets; the men rushing to their places, unstacking and shouldering their guns; the rattling of tin cups against canteens; the regimental colors folding and unfolding in the brilliant light, and the dull, swishing sound which thousands of feet make when rushing through tall grass. Together with this could be heard the loud commands of the officers in charge of the battery, the deafening roar of the guns and the scream of the shells as they tore on their way toward San Juan."

Journalists watched from a safe distance as the attacks unfolded up the heights of San Juan and Caney, although they occasionally had to take cover as Spanish shells came over and in one instance a shell burst over the heads of a group of attachés and correspondents forcing them to flee for safety. Seppings Wright lost his saddle-bags, sketches, books, stamps and everything else when a shell exploded above a group of horses including his, sending them stampeding into the dense bush. Some correspondents like Christy moved towards the front to get a better view but were unprepared for what they saw for the roadside ahead was crowded with wounded American soldiers picked off by Spanish sharpshooters. Up on the heights, the deadly carnage continued and the observers could see men falling down into the tall grass.

Others hit by Spanish artillery were thrown into the air to fall bleeding from loss of limbs and deep wounds. Some were struck by their own shells as they were within yards of the Spanish lines on San Juan and those that succeeded in breaking through were hit by deadly fire from the blockhouse. The heights were taken shortly after and the village of Caney by mid-afternoon. It was now time for the correspondents to swarm over the battlefields to record the events. Christy made numerous sketches which he later developed for publication. Glackens, Remington and the other artists were busy making their visual records of the scenes while photographers posed groups of soldiers or snapped the empty Spanish trenches. It was left to the artists to capture the action in their sketches as the cameras of the day could not capture movement.

In the days that followed leading up to a truce of July 10 and the surrender of Santiago on the 17th, the correspondents finished off their written and visual reports of the battles of July 1. There was little action to report other than the bombardment of Santiago though the area was still infested with Spanish sharpshooters. The surrender itself irked many correspondents. As Charles Sheldon, a British artist-correspondent who worked for both *Leslie's Weekly* and the London illustrated weekly, *Black and White*, explained:

Charles Sheldon in camp near Caney, Cuba, from a photograph in *Leslie's Weekly*, 1898

"Yesterday, the actual ceremony of the surrender took place, but very few of the correspondents succeeded in seeing it. General Shafter, the day before, told us all that none of us were to go into Santiago, on pain of being put into irons, punctuating his orders, in his usual well-bred

and picturesque fashion, with decisive oaths...Some ten or a dozen of our possible hundred, however, sneaked in, and Shafter and his staff said never a word to them. However, he was obliged, on the strength of that, to give the rest of us leave. So we went in immediately afterwards."[5]

Within days of the surrender, the various teams of correspondents began to leave Cuba but not before witnessing scenes of the aftermath including the refugees and the suffering brought on by the war. But few were in any fit state to do anything about it for many were suffering the effects of fatigue or yellow fever. Sheldon, who fell ill after the surrender, revealed the hardships the correspondents had to endure during the campaign in a letter written on July 3 three miles from Santiago:

"We correspondents have really been down to hard-pan campaigning. We have been obliged to pack on our backs our blankets, ponchos, three days' grub, water, materials, camera, etc. It rains every afternoon in torrents, so that we have difficulty in getting a fire at night to cook over for ourselves, wash our clothes (having no spare ones), when we can. I haven't had a shave since leaving the ship, of course. My one shirt is ragged, my boots are full of holes, and I look more like a *reconcentrado* than anything else. This book and a few pencils, four rolls of film and my camera, are all the materials I have to get me through this business. We have lived on hard-tack and "sowbelly," and part of the time on half rations. The correspondents have no consideration whatever show them now. Headquarters will not take their letters, and I am obliged to trust this to a carrier going to the post, who promises to post it. All my envelopes and stamps have been spoiled by the damp and the rain. I begged the envelope this is going by from one of General Garcia's staff. This is all I have time to write at present. I hope by the time I have my next batch ready that we will have Santiago, when we may be able to get our baggage and supplies."[6]

William Bengough, an artist for *Collier's* and *Harper's* was on board the "Aransas" along with Macpherson and a number of other journalists and attachés as it sailed from Santiago for Tampa on July 20, and he described the conditions of the passengers:

'We were a depressed assemblage: weeks of dirt, disorder, disgust, danger, disease and death had left their marks. The fever was with us; men who had kept up throughout the campaign succumbed on the ship, and out of sixty-five passengers those who remained well could have been numbered on the fingers. Usually the time hung heavy. Yellow fever threatened, and each day saw new victims of the first symptoms of malaria."[7]

Glackens succumbed to malaria aboard the transport back to the mainland and was unable to "work up" his battlefield sketches until quite some time after the signing of the peace protocol on August 12. As a consequence only a handful of his pictures were published in the last few months of 1898 and in several issues in 1899 because of the editorial policy not to publish much about the war afterwards due to a perceived lack of interest. To add to this dilemma, Glackens was paid only for the pictures which were actually published.

Two days after the battles for San Juan, the Spanish fleet which had been anchored in the protective sanctuary of Santiago harbor, sailed out and was met by Sampson's fleet which lost no time in destroying it, sinking several ships in the process. It was almost two months to the day since Dewey's victory at Manila Bay. Both events were duly recorded by the press although Dewey's victory was observed first-hand by only three correspondents, one of whom was the artist for the *Chicago Record*, John T. McCutcheon, who was aboard the cutter "McCulloch" at the rear of the squadron. Admiral Cervera's defeat at Santiago Bay was viewed by a number of correspondents including Carlton Chapman. Unfortunately, Henry Reuterdahl had been forced by fever to return to Key West just days before the battle. Back in New York he continued to draw naval scenes from the war but based on accounts. It was generally left to the staff artists back in the States to concoct images of the naval battles, and they succeeded in creating pictures guaranteed to fuel enthusiasm for the war as well as creating the war's first major hero, Admiral Dewey. At the beginning of June, *Truth* announced that James G. Tyler had finished a picture of the Manila Bay battle "drawn from telegraphic description", and a color plate of the painting was presented free with each issue of the magazine on June 8. The military artist and illustrator, Gilbert Gaul, produced a large picture of the battle which was reproduced in *Collier's Weekly*, while *Leslie's* published "a picture worth keeping" in October showing Dewey's victory, painted by Frank Schell composed from sketches and descriptions apparently supplied by eye-witnesses.

The victory at Manila Bay in May ushered in the beginning of operations against Spanish forces in the Philippines. Although this was a sideshow to the main events in Cuba, in terms of troops involved, the casualties, and the result, it was a much larger campaign and led directly to the Philippine Insurrection which lasted from February 1899 until July 1902. The Americans were there to assist the long-suffering Filipinos to gain independence from Spain, but with the defeat of the Spanish the native population found themselves once more under foreign rule. Under their leader Aguinaldo, the Filipinos fought a desperate war against the *Yanquis* resulting in the death of 250,000 civilians from hunger and disease, a further 20,000 in combat; 5,000 Americans died and 3,000 were wounded out of a total of 60,000 troops who served during the insurrection. The events in the Philippines and the short-lived campaign in Porto Rico in 1898 were covered in the press although to a much lesser extent than for Cuba, and only a handful of artists were on hand to record the events. There were a number of photographers on campaign such as William Dinwiddie and the papers also used soldier's photographs as a source for studio drawings. G. W. Peters, artist-correspondent for *Leslie's*, sailed with the invasion force under General Merritt from San Francisco to Manila in July 1898; Sydney Adamson covered the latter part of the campaign for the paper. *Harper's* sent T. Dart Walker with General Miles's force when it invaded Porto Rico, along with Carlton Chapman. Frederic Remington joined up later with John McCutcheon to cover the operations in the Philippines following the end of the Cuban campaign.

Back in the States the war was followed with immense interest and it was not uncommon to see persons sporting war badges including 'Maine Revenge' pins in their buttonholes. Dime novels abounded with titles such as *Young Glory's Gun-Boat; or Running the Santiago Batteries*. Enterprising impresarios began to show "moving images" of the war although many of these were faked footage of fighting. Charles Dickson's 'Biograph War Views' included scenes in and about Havana and the departure of the troops "in actual life motion". Edison's War Graph was another, while at the 'Warograph' scenes of the siege of Santiago were shown hourly between 10 and noon, and 2 and 5. Theatrical

productions were staged. At Chicago's Coliseum Gardens, Pain's Great War Spectacle *Cuba* was shown every night with pyrotechnical battles of Manila and Santiago, although at one point, the license was revoked because of the danger presented by the fireworks. Later a vaudeville and farce comedy entitled *The Fall of Santiago* played nightly in Chicago, while music hall performers gave renditions of new patriotic songs. Within a few months of the war's end, some large panoramic paintings went on exhibition. Advertisements for a spectacle entitled *Battle of Manila* at Boston's New Downer Landing in August 1898, invited the public to witness "ships blown to atoms" and aerial fireworks never before seen. The Electro-Cyclorama in Chicago depicted the battle of Manila Bay with Dewey on the bridge of the "Olympia", and the public was informed that it took six months to prepare by artists from Paris and London. In New York, Pain's Manhattan Beach amphitheatre displayed a large panorama during June and July, 1898, of the fall of Manila replete with firework displays.

Huge maps were exhibited above newspaper offices in New York, Chicago, and elsewhere and the latest telegrams in very large type were posted attracting vast crowds daily. The weekly Sunday World's *Pictorial History of the War with Spain* included photographs, drawings and color plates of the events. Many of the newspapers and magazines offered war maps and charts with flags to move around showing the progress of the army and navy. Souvenir prints and photographic plates with war themes were advertised as an incentive to new subscribers, and both *Leslie's* and *Collier's* published colored lithographs of the battles for sale. Photogravures of U.S. naval ships were issued by, among others, the *Boston Sunday Herald*, while some companies used scenes from the war to advertise themselves. At the cessation of hostilities, both *Harper's* and *Leslie's* published folio illustrated histories of the war.

Commercial print makers produced patriotic, albeit completely incorrect chromolithographs of the war. Notices of pictures appeared in the papers. M. T. Sheahan's "War Novely Pictures" published in Boston included color prints of the U.S.S. "Maine" at 25 cents a piece, the "Maine" before and during the explosion for 10 cents, and a composite portrait of General Miles, Admiral Dewey and Admiral Sampson. The Pastelo Type Company in New York offered 11" x 16" prints of war heroes for 10 cents each or 100 for $3.50. Some of the last prints issued by the famous company of Currier and Ives depicted scenes from the war including *Our Victorious Fleets in Cuban Waters* and an equestrian portrait of Roosevelt in his 'Rough Riders' uniform. Louis Prang's Boston company issued a print titled *Manila Bay, 1898* and *'Dash for Liberty, Santiago Harbor, 1898'*, while the renowned chromolithographic company of Joseph Hoover of Philadelphia issued souvenir prints such as *Bombardment of San Juan May 12th 1898* by the Civil War veteran-artist, Xanthus Smith, and Albert Henke's picture of the battle of Malate. But perhaps the most colorful pictures were published by the Chicago company of Kurz and Allison in 1898 and 1899. Probably designed by Louis Kurz, they did not pretend to mirror the actual events but rather attempted to tap people's patriotic emotions. In a similar vein were several illustrated histories of the war containing colorful but wholly inaccurate renditions of the fighting. One such example was the *Pictorial Atlas Illustrating the Spanish-American War* published in Chicago by the Souvenir Publishing Company.

Several artists created studio paintings depicting the war. As early as July, 17, 1898, a large oil painting entitled *The Rough Riders in Battle* by F. Mortimer Lamb, described as the "first painting of the Spanish-American war to be placed on exhibition in this part of the country", went on public display in the vestibule gallery of the Boston Theatre. The marine artist, Warren Sheppard, received a commission to paint Dewey's victory and visited Pain's panorama on July 2 for inspiration. Rufus Zogbaum who had covered the movements of the North Atlantic Squadron, turned his attention also to the victory at Manila Bay in a large canvas showing the admiral peering through the smoke of battle from the "Olympia's" bridge. Edward Kirby painted a naval battle scene probably relating to the Cuban blockade, while James G. Tyler who worked for *Truth* and painted the battle of Manila Bay for the magazine, later produced a canvas showing U.S.S. "Vixen" firing on the crippled Spanish cruiser "Viscaya" at the Battle of Santiago during the war. There were a few depictions of the land battles. Roosevelt and the Rough Riders were depicted at the church of San Luis after the battle of El Caney by Lyell Carr who apparently was present,[8] and Harper Pennington, a relative of Major General Hamilton Smith Hawkins, represented the general at San Juan Hill. For his part, Remington completed a few canvases based on his experiences, the most significant being a painting of the Rough Riders charging up San Juan Hill.

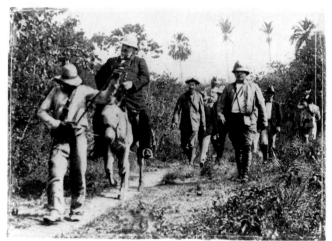

Frederic Remington (right) in the train of General Shafter, from a photograph in *Harper's New Monthly Magazine*, 1898

Perhaps the most celebrated foreign artist to portray the war was the Russian military painter, Vasili Verestchagin. He had experienced combat himself and had devoted his career to exposing the horrors of war through his paintings. In 1901, the artist spent more than two months covering the Philippine Insurrection and his sketches were later worked up into finished canvases depicted, among other things, General MacArthur and his staff watching the battle of Caloocan, the battle of Santa Ana near Manila, and the fight at the Zapote bridge.[9] However his most poignant pictures of the war were set away from the battlefield. These five oval scenes included *The Interrupted Letter: A Poem in Paint*, showing a cavalryman saluting with blood pouring down his face, *The Letter is Interrupted*, in which a wounded man has fallen back on his pillow while a nurse anxiously feels his pulse, and *The Letter Lies Unfinished*, the paper lies forgotton on the floor at the foot of the bed where the writer lies stark. These scenes were witnessed by Verestchagin in a Manila hospital and so moved him that he chose to capture the images. Two other Philippine pictures show drumhead court-martials, one indoors, dealing with a deserter, the other outdoors showing the interrogation of a spy clad in a light uniform. Towards the end of 1901, the

artist travelled to America, and in the following year made two trips to Cuba to make sketches for a series of war pictures. Roosevelt himself, posed for one of these pictures showing the capture of San Juan Heights, provided Verestchagin with details and photographs, and visited the artist's studio on several occasions.[10]

Finally, several soldier-artists created pictures based on their experiences. Corporal F. Sewall Brown of the 1st California Volunteer Infantry carried a sketchbook in his haversack throughout the campaign for Manila, and in the following year published his sketches in *The Soldier's Sketchbook*. Charles Johnson Post, a soldier with the 71st New York Volunteers kept two sketchbooks throughout the Cuban war and managed to smuggle them through Montauk Camp. With these sketches and his strong visual memory, he was able to paint a series of pictures showing the fighting.

The war inspired a vast amount of illustration in the weeklies, the dailies, and in popular prints. While the pervasive atmosphere in America during the war was jingoistic, this did not creep into the visual journalism of the conflict although it was displayed overtly in many of the commercial chromolithographs designed to tap people's patriotism. Artists who went to the front were unprepared for what they saw and this affected what they drew. Quite simply, they produced what they witnessed; there was no place for imagination not when they watched as soldiers were decimated by bullets and shrapnel. As Richard Harding Davis stated, the artists and the correspondents who covered the war cared for soldiers when they were wounded, helped by reconoitring, scouting, and in some instances, fighting. They had no uniform to protect them and if captured, they would have certainly been shot for spying. "They were bound, not by an oath, as were the soldiers, but merely by a sense of duty to a newspaper, and by a natural desire to be of service to their countrymen in any way that offered."[11]

◆

Endnotes

1 The letter is quoted in Ira Glackens. *William Glackens and the Ashcan Group* New York, Crown, 1957, p. 23. For an account of Glackens' work in the war, see Alan M. Fern, 'Drawings by William Glackens', in Renata V. Shaw (ed.) *Graphic Sampler*. Washington, Library of Congress, 1979, 251-261.

2 Rufus C. Zogbaum, 'The Bombardment of Matanzas', *Harper's Weekly*, May 21, 1898, 501-502.

3 *Illustrated London News*, June 4, 1898, 812.

4 Fern, 255.

5 Charles Sheldon, 'The Horrors of War', *Leslie's Weekly*, August 18, 1898, 135.

6 Charles Sheldon, 'Just before Santiago's Surrender', *Leslie's Weekly*, August 4, 1898, 94.

7 William Bengough, 'Returning from the Santiago Campaign', *Collier's Weekly*, August 14, 1898, 20-21.

8 See illustration of Kirby's picture in *Art of the Civil and Spanish American Wars*. New York, Kennedy Galleries, 1980, plate 54.

9 Isabel McDougall, 'Verestchagin in the Philippines', *Cosmopolitan*, Vol. XXXIII, No. 2 (June 1902), 148-152.

10 Vahan D. Barooshian. *V. V. Verestchagin. Artist at War*. Gainsville, University Press of Florida, 1993, 147-148. For a depiction of the San Juan picture see 'Verestchagin, Painter of War', *The American Monthly Review of Reviews*, Vol. XXIX, No. 5 (May 1904), 549.

11 Richard Harding Davis, 'Our War Correspondents in Cuba and Puerto Rico', *Harper's New Monthly Magazine*, Vol. XCVIII (May 1899), 948.

Newspapers/Magazines

Boston Herald
Century Magazine
Chicago Tribune
Collier's Weekly
The Graphic (London)
Harper's New Monthly Magazine
Harper's Weekly
Illustrated London News
Leslie's Weekly
New York Journal
New York Times
New York World
Providence Journal
Scribner's Magazine
Truth

Bibliography

Bonsal, Stephen, *The Fight for Santiago*. New York, Doubleday & McClure Co., 1899.

Brown, Charles H., *The Correspondents' War*. Journalists in the Spanish-American War. New York, Charles Scribner's Sons, 1967.

Brown, F. Sewall, *The Soldier's Sketchbook*. n. p., 1899.

Chapman, Carlton T, 'The Blockading Fleet', *Harper's Weekly*, May 7, 1898, 450-451.

Chapman, Carlton T., 'Key West', *Harper's Weekly*, May 14, 1898, 478.

Christy, Howard Chandler, 'Christy's Story of the War - 1. A Narrative of Unusual Interest by an Artist of "Leslie's Weekly" who went to the Front with Our Brave Troops', *Leslie's Weekly*, August 18, 1898, 134.

Christy, Howard Chandler, 'The Story of the War - II', *Leslie's Weekly*, August 25, 1898, 154.

Christy, Howard Chandler, 'The Story of the War - III. The March to the Front', *Leslie's Weekly*, September 1, 1898, 174.

Christy, Howard Chandler, 'The Story of the War - IV. Waiting for a Fight', *Leslie's Weekly*, September 8, 1898, 194.

Christy, Howard Chandler, 'The Story of the War - V. The Fierce Battle of Caney', *Leslie's Weekly*, September 22, 1898, 234.

Christy, Howard Chandler, 'The Story of the War - VI. ', *Leslie's Weekly*, September 29, 1898, 246

Christy, Howard Chandler, 'An Artist at El Poso', *Scribner's Magazine*, Vol. XXIV, No. 3 (September 1898), 283-284.

Christy, Howard Chandler, 'Some incidents of the War', *Truth*, April 1, 1899, 98-100.

Christy, Howard Chandler, *Men of the Army and Navy. Characteristic Types of Our Fighting Men*. New York, Scribner, 1899.

Craighead, Alexander McC., 'Military Art in America, 1750-1914, Part VI', *Military Collector & Historian*, Vol. XVII (1965) 76-80.

Davis, Richard Harding, 'Our War Correspondents in Cuba and Puerto Rico', *Harper's New Monthly Magazine*, Vol. XCVIII (May, 1899), 938-948.

Gerdts, William H., *William Glackens*. New York, Abbeville Press, 1996.

Hodgson, Pat, *The War Illustrators*. London, Macmillan, 1977.

Life. 'A Little War with a Big Result: Soldier's Art gives fresh look at our 1898 fight with Spain', *Life*, 1958.

Longuski, Holly Christina, *Howard Chandler Christy and the Spanish American War* (unpublished typescript, 1997).

Macpherson, Douglas, 'Santiago - Some Side-Lights', *United Service Magazine*, (October 1898), 138-144.

'The Newspaper Correspondents in the War', *The American Monthly Review of Reviews*, Vol. 18 (October), 1898, 538-541.

O'Toole, G. J. A., *The Spanish War. An American Epic - 1898*. New York, W. W. Norton & Co., 1984.

Post, Charles Johnson, *The Santiago Campaign. An Exhibition of Paintings under the sponsorship of the Chief of Military History*. Department of the Army, December 5, 1952-January 4, 1953. (Washington, Smithsonian Institution, 1952). 8 page pamphlet.

Post, Charles Johnson, *The Little War of Private Post*. Boston, Little Brown, 1960.

Remington, Frederic, 'With the Fifth Corps', *Harper's New Monthly Magazine*, Vol. XCVII (November 1898), 962-975

Russell, Walter, 'An Artist with Admiral Sampson's Fleet', *Century Magazine*, Vol. LVI, No. 4 (August 1898), 573-577.

Russell, Walter, 'Incidents of the Cuban Blockade', *Century Magazine*, Vol. LVI, No. 5 (September 1898), 655-661.

Douglas Macpherson:
a British Artist-Correspondent with the American Army, 1898
by Frederic A. Sharf

◆

On Saturday, April 9th, 1898, the steamship "Campania" sailed from Liverpool to New York City. Among her passengers was a British artist, who had hastily been assigned by his employers, the proprietors of the London newspaper *The Daily Graphic,* to proceed to America. Macpherson had been on the staff of this newspaper since it was launched in 1890.

While there had not been as yet any official announcements of war between Spain and the United States, it was assumed by the media that a war was imminent, and *The Daily Graphic* wanted to have their staff on site in advance. At the same time that Macpherson was sent to New York, another artist-correspondent Sidney Higham was sent to Madrid.

Macpherson had no prior experience covering military campaigns, although he was accustomed to dealing with military material in working up sketches and photos sent from various campaign locations. However, the proprietors of *The Daily Graphic* had no options; their experienced military specialist, William Theobald Maud, had just returned from covering operations on the Northwest Frontier, and was about to leave for the Sudan to accompany Kitchener in his final drive towards Khartoum.

The haste with which Macpherson received this assignment can be inferred from the fact that on Saturday, April 2nd, he had been covering a Ten Mile Amateur Championship Road Race in a London suburb: his drawing of this event appeared in *The Daily Graphic* on Monday, April 4th. Meanwhile, he had received his first Spanish-American War assignment to depict the American fleet, and on Wednesday, April 6th his drawing of the United States Navy was published. The drawing depicts 40 ships of all types, and was obviously constructed from photographs.

Macpherson reached New York City on April 17th, immediately mailing back his first dispatch; and then proceeded directly to Tampa, where the American army was assembling. It is likely that he departed by train on April 18th, and reached Tampa in the late afternoon of April 21st. By April 22nd, it was clear that war would take place, and many regiments of troops from the regular army had already reached Tampa, and had established camps.

On Thursday, April 21st, knowing that Macpherson's arrival in Tampa was imminent, *The Daily Graphic* proudly announced:

"In view of the probable outbreak of War between Spain and the United States, the Proprietors of *The Daily Graphic* have made SPECIAL AND COSTLY ARRANGEMENTS for reporting and illustrating hostilities, both by land and sea, and for the rapid transmission of news."

While many correspondents maintained a room at the Tampa Bay Hotel, and were content to cover the war preparations from a rocking chair on the porch of the hotel,

Macpherson managed to attach himself to the 4th U.S. Infantry, whose camp was located at Ybor City, a suburb of Tampa.

The 4th U.S. Infantry, together with the 1st and 25th, composed the Brigade of the Second Division. Colonel Evan Miles was the Brigade commander, and General W.H. Lawton was the Division commander. Macpherson was thus able to give his readers a very first-hand account of the preparations.

When orders were received on June 7th to proceed to the troop transports, Macpherson accompanied the 4th U.S. Infantry on a three mile march from Ybor City to West Tampa, followed by a nine mile train ride to Port Tampa. The 4th was the first unit to board the transport S.S. "Concho", and they were joined by the 25th, thus filling the ship. The ship sailed with 53 officers, and 1034 enlisted men...plus Douglas Macpherson!

An officer of the 25th described the S.S. "Concho" has having been hastily fitted out for troop transport, and thus very uncomfortable. After a false start, initiated on June 7th, the ship finally sailed on June 14th, and arrived off Santiago in the morning of June 19th. They remained in the rough waters off Santiago until disembarkation began on the morning of June 22nd...by which time many men on the ship were seasick.

Macpherson's reports from Santiago speak for themselves. It is important to note that these reports often took four weeks to reach London; thus, publication took place long after the events. Often several reports arrived in the same mail, and the editors of *The Daily Graphic* would determine how to spread them out over several daily editions of the newspaper.

Macpherson was one of the few correspondents fortunate enough to remain with the American Army as it entered Santiago; and thus fortunate enough to actually witness the ceremonies of Sunday, July 17th. Unquestionably, this was the result of Macpherson having endured the hardships of army life from the moment he joined the 4th U.S. Infantry at Tampa.

Once the Spanish had surrendered at Santiago on July 17th, there was immediate pressure from the American commanders to get people out of Cuba; disease was becoming a major issue, and repatriation to American shores a major objective. Naturally, the correspondents and attachés were the easiest to send back, and it is not surprising to find Macpherson and a number of his colleagues assigned to return almost at once.

Macpherson departed from Santiago for Tampa on July 20th aboard the transport ship S.S. "Aransas". The ship had left Tampa on July 13th with a cargo of supplies destined for Siboney; arriving at Siboney after the surrender, the ship unloaded its cargo at Siboney, and was ordered to proceed at

once to Santiago. A cargo of tents for the American soldiers had been unloaded at Siboney.

According to William Bengough, correspondent for *Colliers Weekly*, some correspondents boarded the S.S. "Aransas" at Siboney, and sailed around into Santiago, where they were joined by Macpherson and others. The S.S. "Aransas" was not equipped for passengers; it was accustomed to carrying a small number of military personnel (15 persons) and a large amount of supplies.

When the ship finally left Santiago on July 20th, it was carrying 65 passengers: most of them suffering from the weeks of hardships in Cuba, and many of them actually quite sick. Accommodations were spartan; food was still army food; the threat of malaria and yellow fever hung over the entire homeward trip.

Macpherson appears to have been one of the few lucky passengers to avoid sickness; he organized games of chess for his colleagues, even creating the chess board and the chess men using his artistic talents. Colorful characters were on board: Colonel John Jacob Astor, a member of Shafter's staff; the Russian Navel Attaché who was a Prince; Major Shiba, the Japanese Army Attaché, who occupied himself by making copious notes and maps.

The S.S. "Aransas" reached Tampa Harbour on July 24th. Passengers were disembarked, and the entire ship was fumigated. Then the passengers were re-boarded, and sailed out into the harbour for a five day waiting period; when no infectious disease developed, the ship was permitted on July 30th to finally land its weary passengers in Tampa.

According to Macpherson's account they landed at night, and immediately boarded trains for the trip north; he traveled directly to New York City and immediately on to London. By August 18th, he was back in the London office; he turned in a group of photos which he had taken, and some of these were published on August 19th and 20th. On Monday, August 22, Macpherson was in Wareham, England, assigned to the Southern Army, covering the largest army field maneuvers ever undertaken to that time by the British Army.

◆

Douglas Macpherson's Eye-Witness Accounts
Sent by Macpherson to
the London Office of *The Daily Graphic*

◆

April 17, New York City–THE FIRST WAR NEWS

When the Cunard steamship Campania left Liverpool, on her last voyage to New York, war appeared to be imminent, the greatest anxiety, therefore, prevailed on board as the vessel neared New York to know whether hostilities had been actually declared. The pilot who was picked up as the boat entered the roads of New York Harbour had brought newspapers, and these were caught up by the passengers and eagerly read.

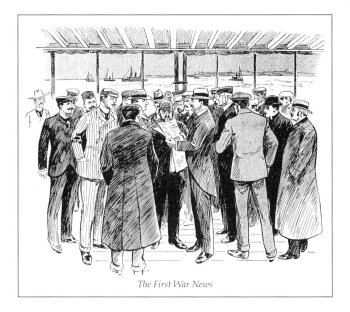

The First War News

April 23, Tampa–WAR SCENES IN AMERICA

Passing through Washington on my way to Tampa, I saw the first indication of the coming war–a trainload of the "Boys," in their smart blue uniforms, with a background of girls in gay frocks waving handkerchiefs, while a band was playing "Auld Lang Syne." At Tampa I found a high festival of the Cuban refugees in progress. They were celebrating the intervention of the United States. It is computed that there are about eight or nine thousand Cubans in Tampa, so there was a good muster. They paraded the streets in a torchlight procession, with bands and banners in the most approved Hyde Park manner, and speeches were made from the bandstand.

One transparency gave a curious specimen of Cuban English. It was inscribed, "Hurroy for Congress, the Army, and the Navy." If one judged the Cubans by the specimens to be found here they would not seem to be a very formidable people, are rather under stature, slight, and evidently very excitable. The girls are extremely handsome, with jet black

hair and large dark eyes. A dramatic incident in the midst of the speeches occurred when a piled-up baggage waggon came through the crowd, the 'boys' of Uncle Sam perched on the top receiving a splendid ovation from the crowd. The Cubans were all well dressed, most of them being of the cigar manufacturer class, who could well afford to leave Cuba. There are also about fifteen hundred Spaniards here, so we have all the elements for a Cuban insurrection in miniature. They are all, however, extremely well behaved, and the weather is too hot for rebellions.

The Olivette left here the other day with 153 Spaniards on board, the vessel having been chartered by the Spanish government to take back all who desired to return to Cuba. Dr. Dudley, who represented the United States Marine Hospital Service, states that as soon as the Spaniards were well out to sea they tore up their American citizenship papers and threw them into the Gulf. They all declared their intention of joining the Spanish Army at once. He also said that the defenses of Havana harbour had been greatly strengthened since he left there with General Lee a short time ago. Four batteries of 15-in guns have been planted on the point half a mile from Morro Castle, and six torpedo tubes have been placed opposite Morro.

April 27, Tampa–WAR SCENES IN AMERICA:
INFANTRY REGIMENTS ARRIVE IN CAMP AT TAMPA

The regular troops ordered to this division–the 4th, 5th, 6th, 9th, 13th, 17th, and 21st Regiments–are now all in and comfortably settled under canvas. Those coming from the Canadian frontier have had a severe climactic test, in several cases leaving snow and ice behind them, in three days being set down in a tropical heat, which even the inhabitants say is phenomenal so early in the summer. They stood it well, however, and notwithstanding the heavy loads they carried (averaging 60 lbs.), the cases of fainting were very few. They have had a most glorious reception through the States, people turning out in crowds at all hours of the night to see them pass through the stations. At Georgia, they tell me, the bunches of roses thrown through the windows were so numerous that you could hardly see the men for roses.

The heavy clothing the troops are now wearing does not seem the best adapted to a warm climate, but a canvas uniform, similar to that of our Indian soldier, is to be supplied before they get to work. The hats will be the same as now worn. To an English eye the troops do not seem quite as automatic and neat as those we are accustomed to see, but there is no doubt that they are of the very best fighting

material: experienced men who have seen a lot of hard service in sporadic Indian warfare. Nowhere have I met so much hospitality as I have seen among the American officers. They have an easy way with them that is extremely fascinating.

Everywhere one hears praises of the British Government for the attitude they have adopted in this emergency, and "John Bull" is just now one of the most popular of beings with "Uncle Sam." I send some sketches of the 13th and 17th Infantry coming into the camp, which is situated about two miles from Tampa. The roads to the camp are simply beds of loose sand, upon which long boards are laid, instead of paving stones. The camp is well wooded, and there is plenty of shade. The first beer cart in the camp did a roaring trade, the owner's stock being sold out in a very short space of time. Washing in camp is accomplished without a basin and with a short allowance of water. You have to get the aid of friend, who pours a little tin of water on your head, and when you have finished, you do the same for him.

Refreshment
A Wash After the March

May 4, Tampa–WAITING TO INVADE CUBA: WITH THE AMERICAN ARMY IN TAMPA

Every day sees increasing activity in Tampa. Troops are concentrating here from New Orleans and Mobile, while several of the regiments are under orders to hold themselves in readiness to embark at a moment's notice. Supplies are being bought, and every trader and saloon keeper is doing a roaring business. The army of war correspondents is also concentrating, and is now assuming somewhat formidable proportions. Over a hundred permits have been issued by the War Department, and still they come. The costumes worn at present by this irregular body are charming in their variety, ranging from tennis flannels, yachting costumes, and light boulevard suits to those of the warlike gentlemen who parade in military canvas kits and bristle with firearms and cartridge belts. Horses and cameras have been very scarce since the advent of the "Specials."

The townspeople appreciate the presence of the soldiery, and the different camps are regular afternoon resorts of amusement. Some musical parade or ceremony usually takes place just before sundown. In the morning the troops are regularly exercised and marched with full kits, in order that they may become properly acclimatized and accustomed to working in the heat of the sun. In the evening military concerts are held at the Tampa Bay Hotel, where is located the headquarters of the staff. The fine hall of the hotel is admirably adapted for the kind of informal levees held by the generals, and the gay dresses of some of the visitors and ladies from Cuba, combined with the uniforms of the officers, help to make up a very gay scene, which gives a pleasant finish to the day of work in the heat and the dust.

All kinds of rumors and beautiful "stories" are published here daily. The difficulty is to extract from them the modicum of truth–if there is any at all. One paper has discovered a Spanish spy of its own, who leaves his house nightly in different disguises. It expects to make a capture shortly. The news of the action at Manila caused a deep sensation here on Sunday, and people were very uneasy until more reassuring telegrams came. The question of the hour is, "Where is the Spanish fleet which is crossing westward?" The feeling is that no movement of the troops is contemplated until this question has been decided in some form by Admiral Sampson. My sketches represent everyday scenes in camp here, and types of the officers and men.

Scenes in Camp

May 11, Tampa–WITH THE AMERICAN ARMY IN TAMPA

An interesting little ceremony took place in the camp of the 6th Infantry Regiment yesterday, the occasion being the presentation of new colours to the regiment by the citizens of Newport, Kentucky. The men were paraded at sundown, the Colonel standing about fifty paces in front of the line, the other officers being at varying distances behind. The colours were escorted from the headquarters' tent, and saluted by the entire regiment. Then a movement–somewhat similar to our trooping of the colour–was gone through, and afterwards the adjutant read the spirited address which had been sent by the citizens of Newport to the regiment.

Last week the "pay-day" call was being sounded through the entire camp by the buglers as a gentle hint to the powers that be that pay was due with the first of the month. I send a sketch of "pay-day" by night in the 4th Infantry camp– a rather unusual scene. The Cubans here in Ybor City are busy arming and drilling. They are not, as yet, all served with arms, the most conspicuous thing about most of them being their

mess-tins and panniers. Those who are armed look strangely out of proportion to their weapons, as these have the appearance of accentuating the diminutive size of the men.

Everybody here is in a state of great expectancy. A movement of the troops is likely to take place as soon as Admiral Sampson's fleet is heard to have met the enemy. All the time transports are continually coming down here by train, to be loaded on the transport ships as soon as possible in order to be ready when the time comes.

May 18, Tampa–"DESTINATION UNKNOWN": EMBARKATION OF CUBAN INSURGENTS AT PORT TAMPA

A little change from the state of oppressive inactivity which has prevailed here for the last two weeks was seen in the departure to-day of 400 Cuban insurgents under Generals Castilio and Le Creto from Port Tampa with destination unknown. They were fully armed with carbines, machetes–broad-bladed swords–and knives, and carried their packs and baggage. The crowd on the quayside was of a rather heterogeneous order, the rank and file of the insurgents, including all sorts and grades, from the swashbuckling Irish-American to the negro native of Cuba. The kits and the methods of fastening them were just as diverse as the complexions of their wearers, being mostly tied on with string and shoelaces. Several United States Army officers were busily superintending the embarkation of the mules and horses, thus imparting an air of solidity to the expedition, while on the upper deck stood two or three men well known to New York society, armed and equipped, ready to take pot-luck with the expedition.

Among the watchers on the quay was a costume which was very noticeable from its distinctive character from all around it. It was that worn by Captain Lee, the British military attaché, who was dressed in the familiar brown khaki uniform and helmet used for foreign service. The Mascot of the Cuban force was a little lad of about thirteen years of age. He was armed to the teeth, and evidently quite alive to the position of importance which he held in the Cuban forces. A lady journalist furnished the comic incident in the scene. She had gone aboard with the inevitable camera, and was so busy down below outvieing her male competitors that she failed to notice that the gangway had been drawn up. The ship was just on the point of starting when she came flying to the side–frantic with the idea of being taken to war–and was picked up and handed over the side into a dozen pairs of hands.

The sketch of Picnic Island camp was taken when the men of the 1st Infantry Regiment were leaving for the Gussie expedition to Cabañas. the trooper of the 9th cavalry is shown in full marching kit. It will be noticed that the sword is fixed on the saddle with its hilt in front, the scabbard passing under the knee. This keeps the sword rigid, and in a very convenient position for the hand. The carbine takes the same position on the opposite side, so that both arms are kept in front of the rider.

May 25, Tampa–STILL WAITING AT TAMPA: THE PRESS CENSORSHIP

Things are much at the same standstill here, with the exception of some slight juggling in the disposition of the troops, some regiments having been withdrawn from the camps, to be replaced by militiamen and volunteers. Since the Gussie incident rigorous restrictions have been adopted in the case of the correspondents, and a strict censorship is maintained. Any correspondent who does not abide by these restrictions is to have his credentials confiscated, and no new ones will be granted to his paper. This is acting as a wholesome check on some of the more irresponsible of the correspondents, who, for the sake of making a "scoop" for their paper, would not hesitate to do so at the expense of their country. At the same time it still more flattens down the news, and there is less excitement round the bulletin board in the town. Meantime several of the New York correspondents and artists have gone back, to wait until signs of movement appear; and some of the London correspondents, in view of the possibility of a long wait, wistfully think of Mr. Kipling's line, "And there ain't no 'buses runnin' from the Bank to Mandalay," changing Tampa, Florida, for the original name.

Yesterday the Queen's birthday was celebrated in the Tampa Bay Hotel by a special luncheon. The Union Flag and the Stars and Stripes were draped together–surmounted by the crescent emblem of the State of Florida–over the table of the staff officers. A band played "God save the Queen" and then the "Star-spangled Banner" and "Auld Lang Syne," all the visitors standing. After lunch the Queen's health was drunk, and complimentary speeches were exchanged. All the transports lying in readiness at Port Tampa were decked with flags in honour of the occasion, as were also two gunboats anchored in the bay, and a general salute was fired at noon by order of General Shafter.

I send sketches of the 4th Infantry at drill in the palmetto, and a battery of artillery drilling near their dusty camp at Port Tampa.

June 1, Tampa–IN CAMP AT TAMPA

Today has seen a change in the aspect of affairs in more than one way here. The state of utter stagnation which inactivity combined with the intense heat had produced upon soldiers and correspondents alike has been dissipated by the scant and uncertain news of the naval battle, followed by sudden orders for preparation for a move. Also the rainy season has commenced in style, with thunderstorm and deluge. Both are welcome, and once more a little interest in life is exhibited. Living in Florida sand has a curious effect upon one, which was well expressed by an old lady who watched from her house a regiment from the North pitching camp and generally "hustling" things into order. "Ah," she said, "you wait till you have been here a week or two, and you will have lost all your ambition." This probably accounts for the slow and leisurely methods of the natives which make the visitors so "tired." It seemed as if we had got right down to business

to-day when a consultation of officers of the 4th Regiment was being held in Colonel Bainbridge's tent in heavy rain the thunder booming like distant artillery.

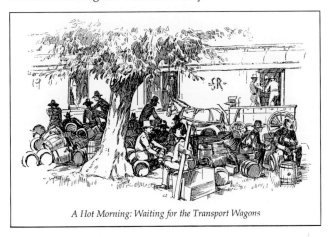

A Hot Morning: Waiting for the Transport Wagons

June 8, Port Tampa–OFF AT LAST! THE SAILING OF THE AMERICAN INVADERS

A move at last! We, in the 4th Infantry, had for two days been holding ourselves in readiness for an order to move. It came yesterday at five o'clock–just at the parade for "mount guard" was commencing–for camp to be struck and everything prepared for the transport waggons at seven o'clock. Wild shouts and cheers burst over the camp when the order became known, and after a hasty supper, a busy scene of packing and rolling bundles for the transports ensued. Bonfires were lighted in all directions for the purpose of giving light ad getting rid of waste litter, the effects produced being most picturesque and weird. All kinds of litter were heaped on the flames–boxes and wooden cots; anything, in fact, that was useless or too cumbersome to take. All were through with their packing shortly after seven o'clock, and then we sat down to wait for the waggons. Some took the opportunity of writing a last letter home before embarking; others indulged in martial songs, sung with great spirit; while a company of warlike spirits executed a Sioux war-dance round a camp fire to a tom-tom accompaniment. Groups of officers were dotted here and there seated on their piles of baggage, looking for all the world like the victims of an Irish eviction. Nine, ten, eleven passed and still no waggons. The singing flagged and became doleful, while muttered anathemas might be heard on the heads of the powers that be, comfortably ensconced in the Tampa Bay Hotel, the laxity of whose arrangements were causing us to sit up unnecessarily in a chilled and dozy condition, or to seek as much comfort as could be obtained out of a bed of ration boxes.

Just as sleep had overtaken us we were aroused by bugle calls through the camp announcing the arrival of the transport waggons, and all was again bustle and activity, til in the pale yellow light of a tropical dawn the dusty mule train slowly pulled out, grey and mysterious. Eventually we were taken down to the quay at Port Tampa by easy stages in troop trains, and there we joined the throng of soldiers, horses, pack

mules, already covering all the available space in a perfect maze of confusion. Things straightened themselves out, however, and when the gear was all on board everybody felt that for one day, at least, he had deserved his dinner. The same process continued happening for the rest of the day, train loads of troops following one another like pack-mules, nose to tail. One feature was the cavalry embarking without their horses; also the belated correspondents who were not allowed to take mounts. A suggestion was made at the mess that Roosevelt's Rough Riders should change their name to Wood's Weary Walkers.

June 19, On Board the Transport "Concha"–
THE INVASION OF CUBA:
THE SAILING OF THE AMERICAN ARMADA

When we were brought down and embarked in such haste upon the transport ships at Port Tampa most of us imagined that we were really starting at last. But alas for false hopes! We were to "lie around" for another week. True we did run out and anchor two miles off in the bay, but only to be roused up in the early hours of the night upon an alarm of Spanish gunboats in the vicinity, and, with the soldiers called to arms, to scuttle back post haste to the snug canal at Port Tampa, like frightened rabbits into a warren. I am not sure that the gunboats were really there, but it is a fact that we were woefully unprotected, and quite at the mercy of any enterprising Spanish torpedo boat that could have slipped upon us under cover of the darkness. The difficulty of the channel amid the shoals, however, was very fair protection against any larger ships of an undiscovered fleet essaying to surprise us.

ANOTHER WEEK OF WAITING.

After that we lay at Port Tampa for seven days, our sole amusement and occupation being divided between sitting on the quarterdeck watching soldiers of various hues from white to black disporting themselves in the water, and sauntering up the long platform at the station, with its throng of heated soldiers and margin of coloured lemonade and ice-cream sellers, with the continual cry, "Ice-cold lemonade, two for a nickel." One man of original bent had invented the following: "Made in the shade, and sold in the sun; if you ain't got a nickel you can't have none!" Sitting in front of the inn one found the elect–Major-General Shafter and staff, a few of the foreign attachés looking a trifle blasé and bored, crowds of officers and their ladies, and some of the *dilettante* correspondents. Mules and horses, with their Arizona and Texan packers, added to the medley, and helped the diversity of a scene which might have been connected with a race meeting for all the serious aspect which the presence of war gave it. One by one the transport ships were disconsolately flying the signal of "water famine," having used up their supply while waiting. The fleet being re-watered, orders were given to proceed, and we emerged from Tampa under a black and threatening sky, the soldiers swarming into the rigging and cheering as each ship drew out. Thus we sailed, a second

"Spanish Armada," destination unknown. In all there were thirty-three transports, including the hospital ship and freightships, carrying a force of about 15,000 troops, and escorted by twelve warships, the Indiana as flagship.

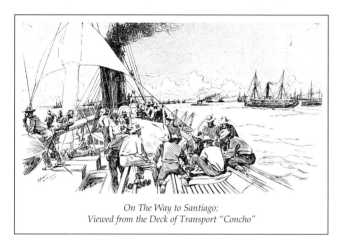

On The Way to Santiago:
Viewed from the Deck of Transport "Concho"

RECOLLECTIONS OF TAMPA

The mobilization at Tampa was certainly an object lesson for the visitor of how things should not be done, brought home to him by hours spent in travelling the short distance from Tampa City to Port Tampa, eleven miles, not to speak of articles of baggage lost amid the general chaos of goods and troops and supplies. Why Port Tampa, with its single line, was selected in preference to Mobile, which has much better railway facilities, is a question only known to the authorities, unless, as Mr. Poulteney Bigelow suggested, it was because the place contained a big, comfortable hotel suitable for the headquarters! One would have thought, too, that the Post office authorities would have risen to the occasion and sent down some special emergency clerks and sorters to Port Tampa and opened additional offices. But, no; the two local clerks, accustomed to dealing with the mail in twenties and fifties, were deemed adequate to meet the influx of mails caused by the presence of thousands of soldiers and volunteers, and were reduced to a case of hopeless bewilderment as they gradually got knee-deep in unassorted letters. Eventually quarter-masters took the matter into their own hands, and with the aid of a sergeant and a file got down on their knees and scrambled for the letters for their own regiments. One's recollection of Tampa, therefore, are chiefly of heat and dust, of confusion, and of famine prices, and it is with a great sense of relief that one enjoys the sensation of steaming along with sunny sky and fresh breeze on the blue sea of the Mexican Gulf.

June 22, Daiquiri–THE INVASION OF CUBA: ARRIVAL OF THE AMERICAN ARMADA

To-day a landing of the troops was effected here without opposition. We arrived off Santiago harbour on Monday morning, having had an uneventful though not unpleasant voyage. As we approached the harbour, and with our field glasses could distinguish the masts and smoke stacks of the blockading fleet just visible over the horizon, one became conscious of a feeling hitherto lacking, that of being in the presence of a real enemy. This was emphasized when some gun-fire smoke rose from the distant fleet, and was responded to by the forts behind the hills.

Orders were given for the fleet to cruise away south-west for that night, however, and yesterday we lay some ten miles away while arrangements were being completed for the attack. By four o'clock this morning the men were all in the boats, and with the dawn the fleet was gradually drawing towards the place selected, Daiquiri, about twelve miles east of Santiago de Cuba. A beacon was seen burning on the hill of the look-out, probably a signal to Santiago that the fleet was here.

DAIQUIRI BOMBARDED

Soon columns of smoke began to rise from the town, the Spaniards firing many of the buildings before leaving. At about ten o'clock the warships New Orleans, Detroit, Annapolis, Marblehead, and Bancroft commenced the bombardment of Daiquiri, the flagship New Orleans opening with the first gun, which was received with a cheer throughout the fleet of transports. A hot bombardment of the hills was maintained for about forty minutes. Meanwhile, fleets of boats full of soldiers ready for battle were being towed up by pinnaces under cover of the warships. It was interesting at first to mark where the shells from the different guns struck, but the ships soon became mere shadows enveloped in a curtain of smoke, which mounted up until it entirely obscured the range of hills behind, lifting here and there, and showing brown puffs of smoke where shells were striking the rock. A blockhouse situated on the spur of the hill overlooking the town was the subject of much attention, numerous shots raising small clouds of dust and splintered rock around it. Owing to its elevation and being rather over the ledge, it escaped demolition however, and was used later as the pedestal for the waving Stars and Stripes. All the cannonading failed to evoke any response, and it soon became evident that the town and the neighbourhood were completely deserted to their fate.

THE STARS AND STRIPES HOISTED

Presently the warships approached the small harbour, and the task of disembarking 15,000 troops in a choppy sea and landing them through surf was begun and merrily continued until dusk. The crowning point of a successful day's work was reached when the Stars and Stripes were raised over the blockhouse to which I have already referred. This was the signal for the tooting of all the sirens on the transport ships, reminding one of the noise heard after the Oxford and Cambridge boat race on the Thames. Thus on the anniversary of the Jubilee procession I was enabled to view a spectacle almost equally imposing, though of a vastly different character!

THE ONLY ACCIDENT

Some of the transport captains seemed to have a magnificent disregard for the safety of their freight, judging from the manner in which they jostled and crowded their ships one upon another, and it is nothing short of a miracle that there was not some serious collision between them. There was one casualty in the disembarking–two men in their eagerness to get ashore fell into the surf, their accouterments and ammunition so weighing them down that they were both drowned.

June 27, In Camp before Santiago–THE INVASION OF CUBA: THE AMBUSCADE FIGHT NEAR SANTIAGO

After landing, the United States Army was not long in getting to work and having a brush with the enemy. The first march of about five miles to Siboney was through beautiful groves of coconut trees and luxuriant tropical scenery. Close confinement and inaction for two weeks on board ship told considerably upon the men, discarded blankets and tunics along the line of march testifying to the fatigue felt by the troops. To make matters worse a heavy fall of rain came on during the night, saturating everybody. In the morning the 1st and 10th (Black) Cavalry, with the 1st Volunteer Cavalry (Rough Riders), came upon the enemy about three miles out from Siboney. The Spaniards occupied commanding positions upon two spurs of hills with quick-firing guns trained upon the road, and parties lay in ambush along the dense foliage.

THE ROUGH RIDERS CAUGHT IN AN AMBUSH

The regular cavalry were advancing along a road to the right and the Rough Riders on another road to the left. Fire was opened upon the scouts of the regular cavalry, and they immediately formed themselves in skirmishing order, and pushed forward, driving the Spaniards towards the Rough Riders. As the Rough Riders debouched round a corner of the road they received the full force of the quick firing guns, and this caused the havoc in L troop. I hear that Sergeant Hamilton Fish lost his life through standing up to fire in the middle of the road while the fire passed over those lying down. The Rough Riders formed and advanced, pluckily dislodging the Spanish from their position. The cross-fire from another machine gun confused them rather, as they thought their right flank had swung round and were firing into them. A mistake which is likely to occur frequently, owing to the similarity of costume, happened with the Rough Riders. They saw a party of men going over the brow of a hill. Their officers said, "Don't fire: they are Cubans." When the supposed Cubans reached the summit they turned, fired a couple of volleys and disappeared. The black cavalry did conspicuously well in the fight, causing very serious damage to the enemy, and losing only one man killed. Some of the men say that they could not see anything to shoot at, the only smoke showing being that of the explosive bullet which the Spaniards were using. A good many of these cartridges were picked up in the trenches.

THE KILLED AND WOUNDED

During the afternoon the slow and painful procession of wounded continued coming down to the house extemporized as a hospital at Siboney. The dead were buried at sundown by the roadside on the battle-ground. Packs of starved and ragged Cubans on still more starved horses, were winding about in the peculiar silent slouching gait peculiar to the Cuban.

SPAIN'S NEGLECTED OPPORTUNITIES

The Spanish reckoned without their host when they thought they had sufficiently disabled the two locomotives left at Siboney. It was not long before the missing parts were dug out and the engines put in order with their steam up. This is an immense advantage for transport purposes, and one can only think what fools the Spaniards were not to complete their disablement. In fact, the Spanish have not played up to their possibilities and advantages in their defense against this landing; if it had been in other hands an invading force would probably have had a very different story to tell than the United States Army has had so far.

All that day Siboney presented a scene of much bustle and activity, boat loads of men, ammunition, and rations being hauled in over the surf by soldiers, the men rather enjoying this cool employment. It was pitiful to watch the unloading of horses; many of them ill and weak, suddenly slid into the sea, with a half-mile swim through rough water and a heavy surf. No wonder several were lost in the operation. Some of them got loose and swam out seawards, having to be abandoned. Though horses are so scarce here their lives seemed of little importance to the Government.

This part of Cuba seems to be one of the best possible for defensive purposes and worst for invasion. Wooded hills and knolls abound, upon which any number of men could be concealed, while from the roads in many places it is impossible to see further than twenty yards. One of the worst things to encounter is the plant called "Spanish bayonets," a stiff, sword-like plant rising three or four feet high with spikes along the outer edge. These go through clothing and inflict a razor-like cut.

EVERY MAN HIS OWN PACK MULE

Meantime the correspondent on tramp with the army has no drawing-room time of it. Separated from his baggage he is fortunate if he possesses a change of shirt and socks; he is his own pack-mule, and like the snail carries his house on his back; he lives on salt pork, hard tack, and coffee, which he grinds in a tin cup with a bayonet hilt. He spends his day in the vain endeavor to get cool, and his night in a similarly unsuccessful attempt to keep dry and get warm. At the end of three days he is left with two crackers and an inch of salt pork, hoping and praying for the next rations to arrive.

July 3, In Camp before Santiago–THE WAR IN CUBA: THE GENERAL ASSAULT ON SANTIAGO

In the pitched battle of July 1st the United States Army has had an opportunity, and a costly one, of testing the real fighting capacity of Spanish soldiers. From the poor resistance made at Daiquiri and onwards towards Santiago an impression had gained ground that the Spanish Army would not put up much of a fight, and that the taking of Santiago would be a comparatively easy task. But out of an operating army of about 12,000 troops between 1,500 and 1,600 of the flower of the American soldiery are killed and wounded in two days' fighting. True, they have stormed and taken by sheer pluck the strongly fortified positions of the enemy, but the credit is due rather to the individual soldier than to any exhibition of superior generalship. It is always the resource and intelligence of the individual soldier that has to supply the deficiencies caused by inefficient and haphazard arrangements of the staff.

THE INEFFICIENT GENERALSHIP OF THE AMERICANS

On the evening of June the 30th we, in the 2nd Brigade of the 2nd Division, were ordered to break camp and move down to a position two miles from Santiago. On the march the want of arrangements made itself evident, regiments getting blocked and inextricably intermingled on the road, 1st Batallions losing 2nd Batallions, and companies going altogether astray. We, in the 4th Infantry Regiment, had to stand in a narrow, muddy road for about an hour while the 2nd Massachusetts Volunteers passed and got ahead. Such a column as the 2nd Massachusetts presented I have seen nowhere, not even among the Cubans. Marching in single file, they were splashing along in twos and threes and tens and twenties, with space of a hundred yards between. After accomplishing a two mile march in nearly three hours, we waded a watercourse to make ourselves thoroughly comfortable and lay down, as we were to be ready to start before daybreak.

THE FIRST SHOT

Before daylight the divisions were on the march, the 1st Division, under General Wheeler, making for the post of San Juan, the 2nd, under General Laughton, for the town of Caney. At Marianage, a hill crested with a dismantled villa, and occupied by General Garcia as his headquarters, commanding a view of both points of attack, a few correspondents took up a position. It was a magnificent sight, the whole panorama spread out before us, Caney on the right and the strongly situated defense at San Juan on the left, with Santiago behind, and all enclosed with a magnificent range of hills. The opening shots were fired about 6:30 from a battery commanding the fort at Caney. Then started the fusillade and regular volleying of musketry, with the distinct burring sound of machine guns, while nothing could be seen except the shells striking and bursting over the forts and trenches, raising clouds of dust, and one wondered how there could be a living thing left in the trenches to fire. Yet they continued to spit forth flame and destruction.

THE FIGHT AT SAN JUAN

Meanwhile, from San Juan could be heard a perfect roar of artillery and small arms, and one could see the splendid attack by the infantry and cavalry in the face of a deadly hail of bullets. The hill of San Juan is superbly placed as a defensive position, commanding a view of the woods and roads all around which could be thoroughly searched by the telescope and any movement afoot easily discerned. Good advantage was taken of this, and the roads were rendered simple death-traps in many places. Many of the American soldiers met their death at the spot shown in my sketch, which was known as the "Bloody Bend." The bodies of the dead were pulled to the side of the road in order to allow the artillery to pass.

Immediately upon the flag of truce being hoisted a party of foreign Consuls came out from Santiago and held a consultation with general Wheeler.

July 4, In Camp before Santiago–THE WAR IN CUBA: THE ADVANCE ON SANTIAGO

After the fight before Santiago on July 1st, the American troops were considerably harassed by numbers of sharp-shooters, who were posted in the trees. As the troops advanced these sharp-shooters were left in the rear of the army, having employed themselves by firing upon the procession of wounded and picking off any isolated parties that might be passing along the roads. It really became as dangerous to be in the rear as in the fighting line, as smokeless powder was used, and one could never tell from where the shot was fired. Another London correspondent and myself received some special attention from one of these creatures and I must say the experience was far from pleasant. One of the doctors while bending over a wounded man in the hospital was shot in the head and killed. The miscreant who fired that shot was caught and the woods were pretty well scoured, the Spaniards caught receiving very short shrift.

A group of attachés and journalists were on the hill at San Juan watching the fight, when a battery commenced to fire upon the town. Only one shot had been fired when a shell burst almost immediately over their heads, scattering them down the hill to a place of safety. Up the hill could be seen the steady advance of the troops, now halting a moment to negotiate some formidable barbed wire, now working round trees, now limping back in couples, while dark inanimate objects strewed the ground of the advance. At last, about nine o'clock, the position was taken, the Spanish retreating to their next line of defense. All the day the firing went on incessantly; occasionally a deep roar and loud report of a shell denoting that Admiral Cevera's fleet was firing shells into the American forces. The artillery and Gatling guns did excellent work, and the placing of shells was magnificent, but the guns were by far too few for the work on hand.

The lack of proper hospital accommodation is greatly to be deplored. It was, indeed, sad to see the wounded walking, as in many cases they had to do for a distance of three miles

before they could obtain surgical treatment. There was no one to assist or direct them, many wandered far out of their proper course and others–those incapable of helping themselves–were left lying out in the field for hours.

July 5, In Camp before Santiago–
THE STORMING OF SANTIAGO

With the exception of about 1,000 men who were guarding Daiquiri and Juragua, the whole of the American Army (numbering some 15,000) and 4,000 Cuban soldiers were engaged in the assault on Santiago. As I have already said, we correspondents took up a position at a dismantled villa which General Garcia was occupying as his headquarters at Marianage. It was a magnificent sight, the whole panorama spread out before us, Caney on the right and the strongly-situated defense at San Juan on the left, with Santiago behind, and all enclosed with a magnificent range of hills. General Lawton's division was on the extreme right, supported by Captain Capron's battery, General Kent's division being in the centre, while the division under General Wheeler was on the left, supported by Captain Grimes's battery planted on the hill. The forces engaged formed a line which stretched across the whole width of the basin in which Santiago lies, a distance of fully five miles. The Cavalry pressed forward to the right and left, and with one grand rush all along the line carried the Spaniards off their feet, capturing the San Juan fortifications and sending the enemy in full retreat towards Santiago. In this attack the cavalrymen were supported by the 6th and 16th Infantry, who made a brilliant charge at the crucial moment. The advance was up the last steep slope through heavy underbrush. Our men were subjected to a very heavy fire from the enemy's trenches.

CUBAN "BRAVERY"

The attitude of the Cubans during this fighting has filled everyone with disgust. One always sees the Cuban on the march with his gun stuck picturesquely across his shoulder, a mysterious bundle on his back, probably concealing many things stolen from the haversacks left on the way, and his hand to his mouth eating a mango or a piece of hard tack. Before the fight his march was apparently to the front, but during the fighting his face was either turned to the rear, or he was skulking behind hedges. Just at the end of the day's work, when everything had been accomplished, there was great activity displayed about the Cuban headquarters, the Cuban cavalry dashing up and down hill, curbing their horses and gesticulating frantically. I thought they had really got a "move on" and were going to rush in and do the shouting.

FLIGHT OF THE PANIC-STRICKEN

For some days before the advance on Santiago was commenced, parties of panic-stricken men and women–mostly Cubans–fled from the town and sought the protection of the American troops. They were in a pitiable plight, having been for some time short of food.

July 10, In Camp before Santiago–WAR SKETCHES FROM SANTIAGO: THE REFUGEES AT CANEY

The state of affairs at Caney has improved owing to the fact that some rations are now being provided for the refugees. A daily allowance is made of four crackers, an onion–rotten or good is a matter of chance–and a teacupful of sugar. The issuing of the relief causes more distressful scenes than ever, people standing packed as closely as possible, so that they cannot be displaced until the time of distribution arrives, when the patient crowd becomes a surging and struggling mass, everybody trying to squeeze into the church in which the rations are doled out. The change in a day or two upon these people is rather startling: the wild and despairing look of starvation is upon them; eyes are bulging and features drawn and haggard. It is too awful for words! Now that Santiago has capitulated they can return to the city, but it is doubtful whether they would be better off, many of them professing as great a fear of the Cubans as of the Spaniards.

July 12, In Camp before Santiago–THE WAR IN CUBA: A WAR OF "HUMANITY"

It is interesting to mark in the progress of this war of "humanity," as it has been named, the extraordinarily "humane" methods by which it is conducted. The unsuitable clothing provided for the soldiers, the unsanitary way in which they were herded on the transports, to be landed and marched for miles in the heat of the day after being cooped up without exercise for more than a fortnight, is an old story; so also is the unmitigated slaughter of men on July 1st. But it is left for the aftermath of that day to fully emphasize the thought that humanity, like charity, might begin at home.

THE TREATMENT OF THE SICK AND WOUNDED

Very little preparation was made for the wounded. Apparently no more than twenty cases were expected, while absolutely nothing was prepared for the number of sick inevitable after the exposure and hard work of the few days' marching and fighting. Men who had thrown away their kits and blankets in the first bluff of the engagement deeply regretted having done so when shivering in the cold dews of the night, and as a result fever and chill with sunstroke cases have begun to accumulate. Coming down from the front, they were calmly told that the hospital had no place for them, and the poor fellows were sent to a field adjacent to the hospital where a makeshift dispensary had been erected. Here they lay down on the grass or on a blanket if they were lucky enough to possess one, and formed a nucleus of an ever-increasing fever hospital. Small shelters, or "dog" tents, have been put up, and we have several kinds of fever here, including measles and dysentery, and some suspected yellow fever cases, all huddled together in a place that becomes a perfect swamp in a heavy rain. All kinds of regulations were to be instituted with regard to keeping the health of the troops while in Cuba. Camps were to be kept in strict quarantine; no strangers permitted in the lines; men were not to sleep on the

ground; water to be boiled before drinking, and so on. In every one of these particulars has the regulation been violated; not even the commonest sanitary precautions have been observed, and it is a common remark among the English correspondents that not an ounce of disinfectant has been in evidence in the camps during the campaign. The dirt, I suppose, is unavoidable, but to officers of any sense of nicety living in camps and trenches for three weeks without a change of underclothing, and this without necessity, is an offense amounting to indecency.

THE REFUGEES

It is the state of the refugees from Santiago at Caney, however, that brings home the real "humanity" of war. To see wounded men dragging themselves for miles–and some actually accomplished twelve from the front to the base hospital at Siboney–was pitiful enough, but for a truly heartrending spectacle the sight of these poor starving people, many of them of genteel families, Spanish, French, and Cuban negroes, huddled together, not having had a particle of food for four days, was without parallel the most pitiful I have ever seen. Old, decrepit men and women, hardly able to crawl, yet laden with bundles, dragged themselves along the road to Caney from Santiago, young children and women, each loaded with bundles, trooped out when General Shafter sent in his notice of bombardment. Yet the bombardment was not begun, but parleys and truces were indulged in for six days, while the people starved. There were waggon loads of food at Siboney for the purpose of relief, yet for three or four days not one transport waggon could be spared for this work.

CANEY AFTER THE BATTLE

The scene in the square at Caney was at the same time one of the most picturesque. The quaint old church, loop-holed for firing, and battered by the shells from our guns, is surrounded by the characteristic red-tiled verandah houses, and rough palm leaf shacks in the centre of the square, a huge tree covered with brilliant red blossom giving shade to the many coloured multitude. Inside the church there was a particularly strong contrast to the brilliance of colour outside. Along the crumbling aisles lay some twenty-five wounded Spanish soldiers, some upon old sacks, a few in hammocks or cots, their blue-grey uniforms harmonizing with the cool gloom of the interior. The vestry of the church was in charge of a fat man with a red cross badge; he was the distributing officer. A young woman lay on one side in a prostrate condition from starvation, some sacks of flour in one corner, and barrels of light cotton goods in another a guard, composed of the inevitable Cubans, posing over their guns at the door. Outside the entrance to the churchyard were ranged long rows of people of all ages, each armed with a tin or pannier, waiting patiently for hours for the expected rations.

WAITING FOR RELIEF

Some special appeals were made to me in French and English–I had long since got rid of all the crackers, sugar, and other provisions that I had in my haversack–to intercede with the officer in charge. The result of my intercession was to elicit the fact that the fat man with the red cross had not had his dinner yet, and had nothing to give away, and I had to scoop out some flour and wrap it in sketch-book leaves to give to these people to stave off hunger until the rations should come. All the conditions at Caney are favorable for the propagation of a mighty pestilence–unsanitary crowding, want of food, and, above all, the terrible smell arising from the ground about the trenches, where heaps of dead men lie just covered with a sprinkling of earth. Joined with this along the road is the odour of saturated and sour heaps of hard tack, rotting cans of beef and mango fruit. What wonder that fever should already begin its ravages with no light hand? The feeling of disgust is strong when one sees a cloud of buzzards hovering over a carcase of a horse or an improperly buried man, but these birds are doing grand work here.

SANTIAGO BOMBARDED

As for the progress of the war, the army has constructed magnificent trenches on the ridge of hills around Santiago, now extending to the waters of the bay. A bombardment was commenced at 4:00 pm on Sunday, the 10th of July. It was a splendid spectacular scene, and one was able to sit comfortably on a hill and watch it with almost as much ease as if it had been at an Earl's Court Exhibition. The firing continued next day in a desultory way, without any reply from the Spaniards, excepting a very few shots from sharpshooters, until about noon, when General Shafter sent in, under a flag of truce, another summons for the surrender of this town. Since the seriousness of the first two days' fighting this campaign has developed somewhat of the burlesque element.

July 17, In Camp before Santiago–WAR SKETCHES FROM SANTIAGO: THE DAY OF SURRENDER

It was outside Santiago on the hills that the memorable scene which will impress itself most strongly on the observer's mind, took place. The immense cordon of troops stretched in a huge undulating semi-circle enclosing the town, the men with faces tanned, clothes torn, mud-bespattered and weather-stained. Their duskiness was set off at intervals by the regimental flags, flashing brilliant touches of colour in the sunlight. Presently a blue-grey cloud was seen emerging from the trees below. It proved to consist of Spanish troops, for whom General Toral had asked permission to camp outside the town. This was the first time that we had seen the enemy at such close quarters, and their movements in choosing their camping ground were watched with considerable interest. At twelve o'clock precisely the regimental bands played the national air, "The Star Spangled Banner." It was a moment which had in it a touch of the sublime.

The victors stood motionless on the earthworks, their heads, cutting the sky line, giving them the appearance of giants. The

officers uncovered, filled with the natural pride which this solemn air evokes in America's boys. Below were the vanquished, watching the lines with a curious but naturally somewhat sad interest. Beyond was Santiago glistening with its brilliant red roofs and white walls, and all round was the magnificent panorama of tropical scenery. Then, when the officers turned and gave the signal to cheer, and a husky roar rolled along the lines and echoed away in the hills, one felt that this supreme moment was worth all the weeks of discomfort and hardship which one had gone through.

Shortly after the ringing cheers had subsided came the anti-climax to the memorable scene. The Spanish soldiers advanced to the line of trenches and shook hands most effusively with their conquerors. Bottles and cigars were passed across between the officers, while further down the line great business in exchange was carried on among the private soldiers. Cigarettes and bottles of rum were offered for crackers, the Spanish soldiers being nearly ravenous with hunger. In one place a cracker box was hardly visible for Spanish hands. In this pleasant way ended a red letter day in the history of the United States and Cuba.

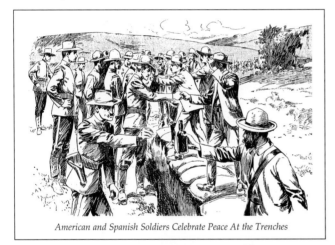
American and Spanish Soldiers Celebrate Peace At the Trenches

July 19, Santiago–HOW SANTIAGO SURRENDERED

Sunday, July 17th, was, at Santiago, a day of great events. On that day the final act of the brief, but arduous, campaign of Santiago–the formal surrender of the army and the city to General Shafter–was consummated. At an early hour the American troops, with flags unfurled, were drawn up in an extended line, on the ridge of the hills facing Santiago. General Shafter, attended by his staff and a troop of the 2nd Cavalry Regiment, rode out about 9:30 along the Santiago road. Turning off into the valley he was met by General Toral and his staff officers, escorted by a regiment of infantry. Here the first little ceremony took place. First there were introductions, compliments, and handshakings exchanged between the officers of the opposing forces. Then the Spanish infantry were drawn up in line, in two detachments, leaving space in the centre for four buglers. They were faced by the United States cavalry, who stood at the salute while the Spanish buglers sounded "Retreat"–a sad call, rendered on

this occasion especially solemn from its serious significance. Then the Spanish infantry wheeled and marched past the American troopers, taking the road back to Santiago, followed by the General and escort.

Nearing the town signs of civilization were observable, many ladies with gay-coloured parasols having turned out to watch the entry; a waggon was even impressed into service as a grand stand. Passing up along the steep, uneven road, trailing through barricades, skirting barbed wire mazes, with Spanish soldiers thronging the houses on each side, the cavalcade arrived at the plaza in front of the cathedral, and here was enacted the ceremony of raising the flag of the United States on the staff on the Governor's Palace. It was a brilliant scene, the flowers in the gardens and the sunshine on the rainbow-tinted limewashes of the cathedral ad houses round about imparting a gaiety of colour which was strongly in contrast with the weather-beaten costumes of the troopers. Inside the Governor's Palace General Toral surrendered his sword to General Shafter, who handed it back to him, and the articles of capitulation were formally signed in the presence of the combined staffs of the two Generals.

July 19, Santiago–CAMPAIGNING IN CUBA: HOW THE CORRESPONDENTS FARED

In one of my recent letters I mentioned a few of the comforts provided for the sick and wounded soldiers in the campaign of Santiago. Perhaps it will not be out of place to remark on a few of the discomforts which the correspondent has had to contend with. Not only has he had to pack himself like a mule, and trudge with all his portable belongings and rations on his back wherever he went, trying to cover all the ground of action, wading knee-deep through streams, along roads ankle deep in mud, and sleeping at night in an outhouse or the trenches; wherever he might find himself he has had to cook for himself and prepare his own quarters, as well as face the more important problem of how to get his work done, and, the most important of all, of getting it "mailed."

The postal organization–like the commissariat and everything else–is a monument of incompetence, and anything more calculated to stop letters reaching their destination would be difficult to imagine. According to the regulations letters must either be stamped, or, if written by a soldier, countersigned by an officer in order to reach home. Most correspondents, like myself, accordingly provided themselves with a supply of postage stamps, to find that they had promptly stuck themselves together in a solid cake, which required a couple of hours to soak, disentangle, and dry, only to suffer in a few days the inevitable fate of being either lost or stolen. After sending one or two packages without stamps the correspondent would be informed by the Post Office official at Siboney that no letters would be forwarded without stamps, and yet there were no stamps in the Post Office to supply him with!

As for receiving any mails, letters might just as well have been dropped in the ocean as when addressed "c/o

Headquarters, U.S. Army, Santiago." The same rule applies to cable messages. No one at headquarters could be bothered at all with anything to do with "outsiders." The correspondent, however, has not been without some recreation. A great deal of his time has been occupied in chasing with a big stick the ubiquitous mule from among the guy ropes of his tent. This has proved a great safety valve to his feelings.

I send a sketch of a camp of English correspondents being flooded out by a mountain freshet after a severe thunderstorm. Cases of tomatoes and beef, crackers, "copy," blankets, shelter tents, haversacks, field glasses–all were swept away, and everybody turned to save them as they went. On went the freshet, right through the fever hospital, dodging and drenching the patients–already wet with the rain. To lie on a soaking blanket–an island in a swamp– while in a raging fever, is not a hopeful condition, but so it unfortunately happened in many cases. My other sketches show the entry of General Shafter and staff into Santiago on July 17th for the formal surrender of the city and of the Spanish army of occupation.

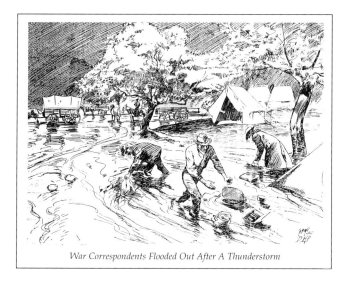
War Correspondents Flooded Out After A Thunderstorm

July 19, Santiago–AFTER THE SURRENDER: ENTERING SANTIAGO

Entering Santiago from the American lines gruesome reminders of the fighting met one at intervals along the road–carcasses of horses, buzzard-eaten and evil-smelling, mere heaps of bones with a bit of sun-dried skin round the hoofs, barely covered over with piles of brush. In some instances they had been set on fire, making a heavy stench of burning rottenness. The refugees were swarming back from El Caney and the surrounding country in an irregular stream, each individual with a bundle on the head, walking quickly or crawling at snail pace, as age or infirmity would allow. Here and there genteel families, ladies with their fans and mantillas, would pass in coaches, or perched together on the primitive cart of the country. The refugees were met by a counter procession–the exodus of soldiers leaving the town to camp outside. Their baggage, rivaling that of the refugees in

its variety, was packed on their small and bony horses. There were piles of clothing and camping gear, surmounted in one or two cases by a joint of fresh meat, difficult to designate, and black, and crawling with flies. One mounted officer had, among other articles draped around his horse, a green parrot and a black fowl tied by the legs behind him. They were unable to reconcile themselves to each other's company even in their precarious position, and were fighting it out merrily as they went along.

No sign of animosity was offered as a few of us rode through the straggling street, the houses of which on either side constituted the Spanish barracks. On the contrary, the men were eager to come and trade with us their "machetes," cigars, and various other things. Quite a business was done with machetes; some of them, having rare and curious handles, were eagerly sought after as souvenirs. The lines of barricades and trenches gave a very dramatic touch to the undulating street and its quaint old one-story houses with overhanging roofs and porticoes. Each house teemed with Spanish soldiers, some swinging in hammocks, some sitting on railings, while others were aiding the boiling of coffee in long rows of iron pots on the ground. Further on we came to a large open square, with a fountain and a "merry-go-round," the latter also swarming with soldiers. At one side of the Plaza, in front of the cathedral, we noticed an inscription, "Restaurant Venus." I realized then the feeling that the traveller in the desert must have when he sees an oasis in the distance. Our desert had been "hard tack" and bacon. The door was closed, as all the cafés were that day by order. By knocking the door was eventually opened, but entrance was denied, no doubt owing to our weather-beaten appearance. An officer, however, gained us admission, and we heartily enjoyed our little meal of fresh fish, steak, and green peas, with cheese and Guava jelly, and a small bottle of wine. We were only allowed a square inch of a kind of rye bread; we could have no more.

Wonderfully kaleidoscopic are the streets of Santiago, with their many hued lime washes, bright blue, pale grey, green,

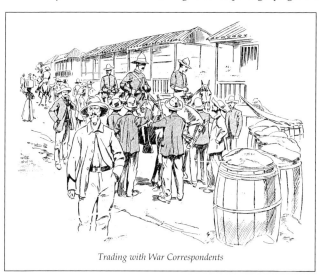
Trading with War Correspondents

buff, and pink and dazzling white, set off by the dusky red tiles, and toned into beauty by weather stains. The character of the architecture, too, with its deep-set eaves and balconied windows suggestive of Old Spain, makes scenes of brightness and variety very pleasing to the artistic eye, and an excellent hunting ground for the sketch book and pencil. The market, opened after the day of the surrender, was a curious spectacle. The wares put out for sale looked at the first glance like little sample piles of grain. It was only on examination that one saw that these constituted the whole stock-in-trade. A few poor and unripe mangoes, with other meagre wild fruits, and small quantities of dry salted cod fish were the only variation. Down by the quay side, the transports were slowly steaming up the harbour. This was a good sight, and visions of clean changes of clothes and recovery of long-lost favorite pipes were conjured up in the minds of the few officers and correspondents on the Plaza, while to the hungry mob of starving Spaniards they meant food and crackers. Eyes glistened, faces relaxed, and even smiles broke out on features which had almost forgotten how to smile.

July 30, Tampa–AFTER THE SURRENDER: SCENES IN SANTIAGO

There was much to interest one in the town of Santiago. There were the few houses that had been struck by shells from Sampson's fleet away outside the harbour. There was the city gaol with its guard of American soldiers, and the shock-headed wild-eyed faces of the prisoners peering from behind the grating in the door of the inner yard.

It was here that Sylvester Scovel was detained until his removal from Cuba, after his escapade on the day of the surrender.

There was the theatre converted into barracks, the quarters of the 9th Infantry, the regiment forming the guard in the town. Stage, stalls, pit, and gallery, even the pay-box, was invaded, and the interior presented a unique appearance with the litter of arms and accouterments.

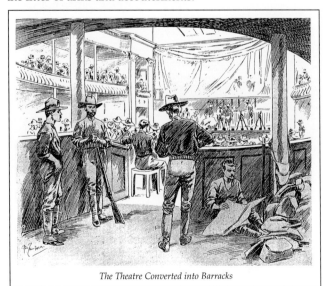

The Theatre Converted into Barracks

The transport waggons coming in to load, with their teams of huge sleek American mules and their stalwart black teamsters, caused no little wonder and interest among the Spanish soldiers and townspeople. By comparison with their own puny horses and undersized and half-starved men, they seemed like beings from another world. However scraggy though and ill-conditioned the native horses might be, the Spaniards managed to get the most out of them. Parties of officers were continually clattering up and down the unevenly-paved streets at a speed that the heavy horses of the American troops would have had difficulty in sustaining in the heat.

Although strict orders had been issued on the subject, many American soldiers were rendered sick from imbibing too freely after their long abstinence of the too seductive rum that was so plentiful in the town, still further complicating the variety of sickness in the hospital camps.

We left Santiago on the transport "Aransas" on July 20th, just when the difficulties of transporting the ever-growing numbers of convalescent sick and wounded were beginning to manifest themselves. On the way out of the harbour we had an opportunity of examining the redoubtable Morro Fort, also the remains of the "Reina Mercedes", and the much-vaunted "Merrimac", the top of a funnel and two masts being all that was seen. From the position of the latter in the stream it was evident that while the bravery of the deed is unquestioned, it was no more effective in blocking the way than if the "Merrimac" had been sunk in mid-Atlantic. Sailing westward out of the harbour we passed the remains of the "Maria Theresa", the "Oquendo", and the "Cristobal Colon". There was something pathetic about these huge vessels, once full of power and motion, now battered and rusted, lying prone and helpless like dead leviathans, at the foot of the beautiful wooded cliffs of Cuba. There were many sad stories told of the campaign of Santiago and these mute, inanimate wrecks told one of the saddest.

Arriving off Egmont Key, in Florida, we had to put in a most uncomfortable week of quarantine. Drifting round a buoy, in torpid, sluggish water, near a coast that sent a miasmic breeze laden with millions of the largest and most rabid mosquitoes that I have ever met, we lay and sweltered and got sick. The convalescents with us suffered from relapse, and those that had gone through the campaign in Cuba in fair health had to give way to this quarantine pest place.

It was reserved for our landing at Tampa, however, for us to fully realize the joys attending the return of heroes. Owing to some ships that were lying at the quay not feeling disposed to allow us room to draw up alongside, and also a little rustiness in the captain's habitual good-nature, we were brought up alongside a coal wharf. Here we had to scramble down, with the aid of slimy piles, carrying our baggage as best we might; then to stagger over a small mountain range of coal interspersed with lakes of water in the dark to get a ferry that was to take us across the canal to the train waiting.

The sight of the Attachés–we had on board the Russian,

Swedish and Japanese–and Colonel Astor performing this feat was distinctly amusing.

As the Japanese Attaché remarked, "it was more difficult to land in the United States than to land in the country of the enemy."

**July 30, Tampa–THE SANTIAGO CAMPAIGN:
SOME RECOLLECTIONS**

To be buried in mud–and the mud of Cuba is none of the sweetest–is not to be envied. It is the fate, however, of many of the poor fellows who were buried where they fell in the battle of Santiago. All along the road from El Poso to San Juan are these soldiers' graves, with just the names written on a cross piece of wood, and a few branches laid down to keep the transport waggons from driving over them.

I send a sketch of General Shafter in the act of being assisted on his horse. Mounting with him was a great feat, usually requiring the aid of three or four troopers, and only performed on state occasions.

For functions less formal, such as an inspection of the position, General Shafter was conveyed in a light four-wheel trolley. This was the more familiar sight as seen from the trenches.

I think I may say that General Shafter earned for himself the title of the "best hated man in Cuba." To be so universally execrated in so short a time as he was is remarkable, and, I think, almost a record. He was as autocratic as the Tsar, and more despotic. His staff, with one or two exceptions, modeled their conduct upon his own. What wonder that anyone under his command, as we were, should have a poor time of it?

Very different, however, and much pleasanter, are one's recollections of the line soldiers and their officers. I have the most unqualified admiration for the American regular soldier. There is no better fellow anywhere. Several times I have found myself in a belated condition–miles away from our little camp, and with the prospect of a long trudge in the dark before me. When I have met soldiers and have asked the way, they have insisted on my not trying to reach home in the dark, but have carried me along to their own camps to share their supper and their shelter for the night. This was the general spirit; one met with it throughout the army. Their pluck, too, their endurance and uncomplaining cheerfulness under trying circumstances are unsurpassed.

◆

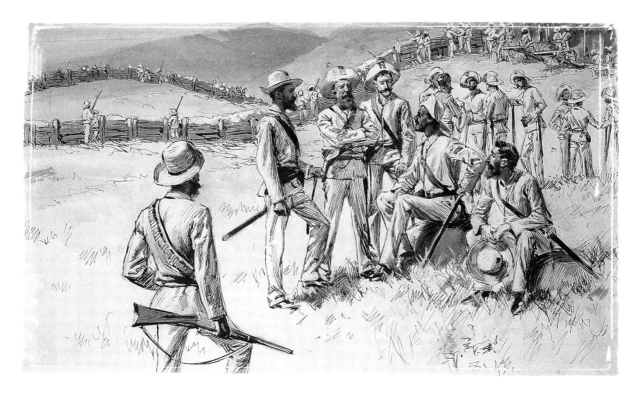

THURE DE THULSTRUP

The Cuban Insurrection: Antonio Maceo's intrenched Camp at El Cuzco, a few Leagues west of the Trocha

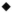

Ink and wash on paper 9 1/2 x 15 in. (24.1 x 38.1 cm.)
Anne S. K. Brown Military Collection (CuO 1896 f-3)

Unsigned but marked lower left: 2

Published in *Harper's Weekly,* June 13, 1896, page 593 from a sketch
furnished by Carlos Valdes, a commander in Maceo's Army.

The cause of Cuban Independence was taken up once again in 1895 with the return of exiled writer,
Jose Julien Marti, and former rebel leaders including Antonio Maceo. In that year, the rebels established
a republic in the eastern part of the island and commenced a guerilla campaign against the Spanish. In 1896,
under General Weyler, the Spanish launched an offensive and began placing civilians in concentration camps.
A large ditch or trocha was also dug as a barrier to the Cubans. By the end of the year, the rebels had been driven
back to the eastern end of Cuba. Americans followed the events on Cuba with intense interest and there was strong
support for the cause of the *Insurrectios*. Material support came in the various filibuster expeditions to carry
arms to the insurgents. These escapades and the fighting were covered by a number of American journalists
who were in Havana, along with reports sent in by the rebels.

Carlos Valdes, a commander in Maceo's army described one of the rebel camps:
"We have two lines of fortifications, made of stone, hard-woods, and sacks filled with gravel,
and we have mounted four Gatling guns and two Hotchkiss. Nature has made our position impregnable;
and from the heights we command a view that extends fourteen leagues on every side."

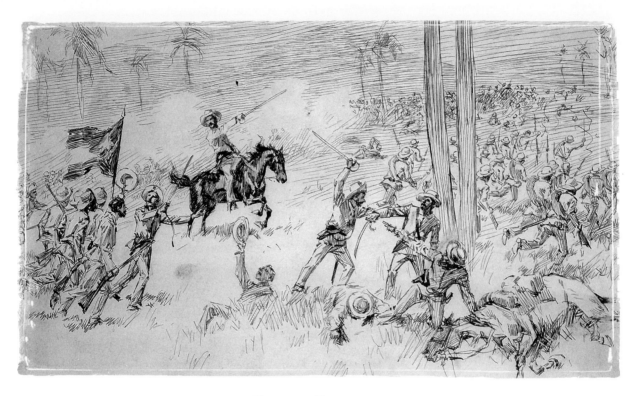

THURE DE THULSTRUP

*The Cuban Insurrection: Insurgents attacking Colonel Debós's
Column on the Cattle Farm called La Legua, April 26 [1896]*

◆

Ink on paper 9 1/2 x 15 in. (24.1 x 38.1 cm.)
Anne S. K. Brown Military Collection (CuO 1896 f-1)

Unsigned but marked lower left: 3

Published in *Harper's Weekly*, June 13, 1896, page 593 from a sketch furnished
by Carlos Valdes, a commander in Maceo's Army.

Valdes, writing on April 27, described the incident: 'Yesterday, we had a hunting party at the expense
of Colonel Debós's, on the cattle farm called "La Legua." We were at breakfast in the dwelling house when
a messenger arrived with information that a column was approaching. Accordingly Maceo arranged that the
cavalry should occupy a position on the further side of the little hill which rises on the right of the farm house.
Colonel Debós's, when he became aware of our position, apparently thought of moving his force up the
hill-side and making a stand there; but as they were passing around a bamboo thicket the cavalry attacked
them. The fight lasted for two hours; then our infantry joined in the attack, advancing by way of the palm grove
behind the hill. Colonel Debós's was seen to fall from his horse, seriously wounded; and thereupon the
Spaniards retreated in the direction of Bromales.' *Harper's Weekly*, June 13, 1896.

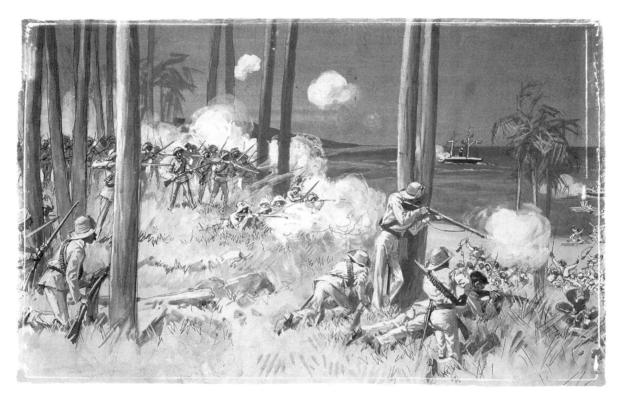

THURE DE THULSTRUP

*The Cuban Insurrection: Marines from the Spanish Gunboats Vigia and Alcedo falling
into the Insurgents' Ambush near the Mouth of the San Juan River [May 12, 1896]*

◆

Ink and wash on paper 9 1/2 x 15 in. (24.1 x 38.1 cm.)
Anne S. K. Brown Military Collection (CuO 1896 f-2)

Unsigned but marked lower left: 2

Published in *Harper's Weekly*, July 4, 1896, page 652
from a sketch furnished by Carlos Valdes, a Commander in Maceo's Army.

Cuban Brigadier, Quintin Banderas, with five hundred men, was placed in ambush near the mouth
of the San Juan River, while a group of fifteen or twenty insurgents, in plain view from the vessels, invited
an attack. Deceived by the insignificance of the visible force, the Spaniards disembarked their complement
of marines, and when these had landed, the party in ambush opened fire, and 'it hailed bullets.'
After an hour and a half the Spaniards retired, leaving eighty-seven dead upon the shore. Valdes writes:
'We were sheltered in the hills that rise above the shore and we knew how to make admirable use
of the advantageous position, for only three of our men were killed and nine wounded.'

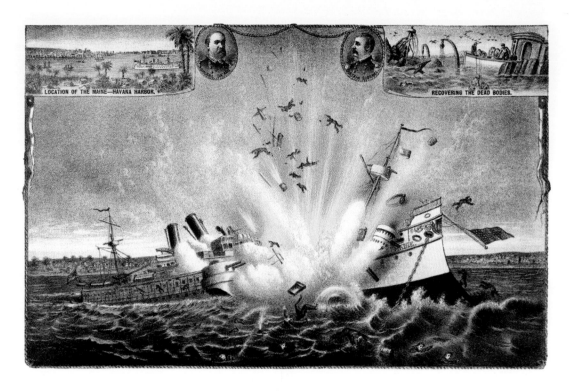

KURZ & ALLISON

Destruction of the U.S. Battleship Maine in Havana Harbor, February 15th, 1898, 9:40 pm

◆

Chromolithograph 10 1/2 x 14 in. (26.7 x 35.5 cm.)
Jean S. and Frederic A. Sharf Collection

Published by Kurz & Allison, pages 267-269 Wabash Ave, Chicago, 1898.

The sinking of the U.S.S. "Maine" in Havana Harbor on February 14, 1898, caused a massive call for war against Spain despite the questionable causes of the explosion which the United States government attributed to a mine or torpedo detonated by the Spanish. Out of the ship's complement of 450 officers and men, 266 drowned.

"Remember the Maine" became the rallying cry for Americans. Patriotic posters and buttons were manufactured to meet the unsatiable demand for revenge. In this atmosphere of jingoism, Kurz and Allison issued this chromolithograph based solely on the imagination of Louis Kurz who was probably the artist.

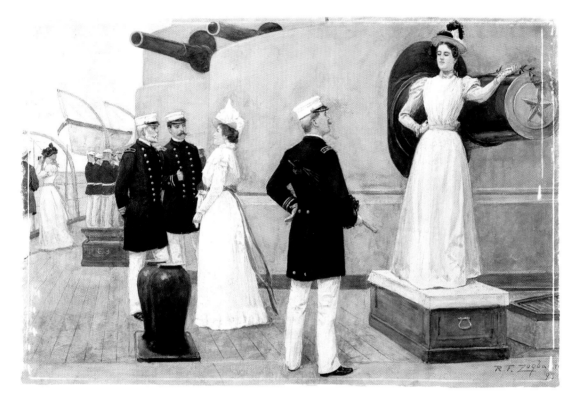

RUFUS ZOGBAUM

12 inch guns

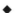

Watercolor on board 14 1/2 x 22 1/2 in. (36.8 x 56.6 cm.)
Jean S. and Frederic A. Sharf Collection

Signed (br): *R. F. Zogbaum '98*

This was one of a series of illustrations painted by Zogbaum for a publication titled *Ships and Sailors*
published in 1898. It appeared as the frontispiece and depicted ladies visiting the battleship.
Similar pictures appeared in the artist's book *"All Hands" Pictures of Life in the United States Navy*
published in 1897 and served to show the public interest in the new navy.

It seems likely that this depicts Key West during the winter maneuvers of 1897/1898 prior to the
repainting of the ships from white to gray for war. The presence of the North Atlantic Squadron
at Key West in January 1898 elicited alot of interest, and it provided an opportunity for
the Navy to show-off the new big guns. Zogbaum probably covered the maneuvers and
when war broke out, he accompanied the squadron on the blockade of Cuba.

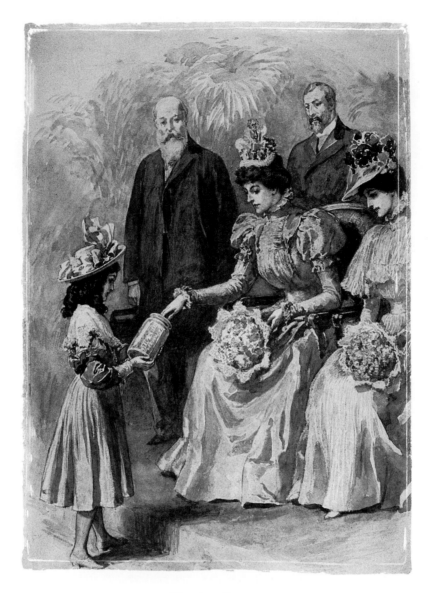

WILLIAM SMALL
(FROM A DRAWING BY SYDNEY HIGHAM)

A Bazaar in aid of the war fund: The Queen Regent taking part in a Lottery

◆

Grisaille on paper 14 1/2 x 10 1/2 in. (36.8 x 26.7 cm.)
Jean S. and Frederic A. Sharf Collection

Signed: *W. Small*

Published in *The Graphic,* July 16, 1898, page 73.

Higham covered the war from Madrid for *The Graphic* and witnessed many events held
to raise money for the war effort including a bull fight. Here, the mother of the Spanish king
is drawing the winning number in a lottery. Higham's sketch was sent to *The Graphic's*
offices in London where it was 'drawn-up' by the notable illustrator, William Small.

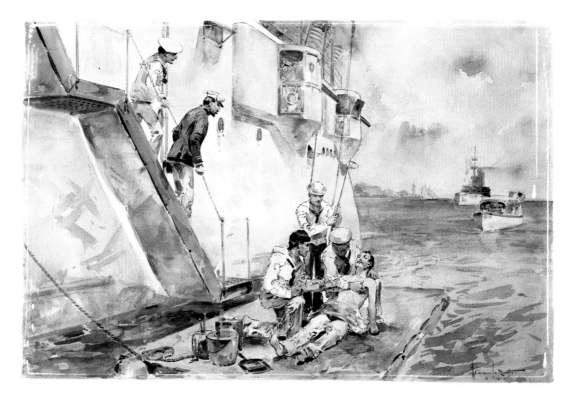

WALTER GRANVILLE-SMITH

Sunstroke while painting ships

Wash drawing 11 x 17 in. (28 x 43.2 cm.)
Jean S. and Frederic A. Sharf Collection

Signed (br) *W. Granville Smith 1898.*
There is no title. A notation on verso in pencil reads: *Reduce to 6 1/2 x 4 1/4 - Great Rush*

An officer descends a ship's ladder to a dock where three sailors are administering to an injured colleague.
Paint supplies suggest they are involved in painting ships. The tropical setting and the white ships suggests
the site is either Key West or the Tortugas, the two primary bases for the North Atlantic Fleet. After the sinking
of the "Maine" on February 15, 1898, the ships at these bases were placed on a war footing, and were painted gray.
Target practice commenced on a daily basis. Sampson's fleet sailed on April 22, 1898 to blockade Cuba.

Granville-Smith painted a series of pictures relating to the navy in the Spanish-American War
but it is not known where these were published. Several do bear notations indicating that they
were lithographed and reduced probably for publication in a book. Smith may have traveled
to Key West to observe the preparations of the North Atlantic Squadron.

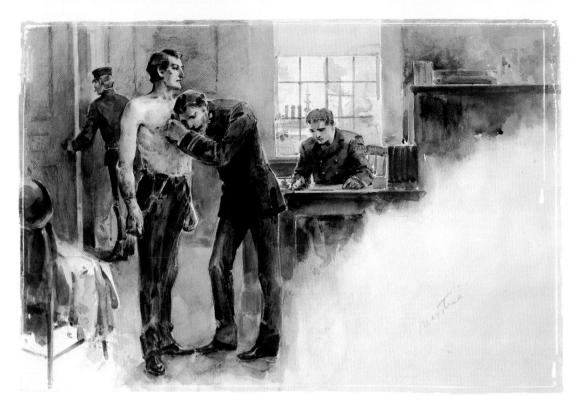

WALTER GRANVILLE-SMITH

Examining Recruits

◆

Wash drawing on board 11 x 17 in. (28 x 43.2 cm.)
Jean S. and Frederic A. Sharf Collection

The title appears on verso in pencil. Also a notation which reads: *Reduce to 6 1/2 x 4 1/4*

The scene shows a recruit having his heart checked by an older central figure, while a younger man
at a desk records the information, and another officer guards the door. On a chair is the recruit's clothing.
A naval base can be seen through an open window. It is not known whether this picture was reproduced
but a photograph in *Colliers Weekly* on May 21, 1898 dealt with the same subject. The navy recruited
men for coastal defense as well as for crews of small vessels for service along the coast.

War was declared on April 21, 1898 and the first call for 125,000 volunteers went out two days later.
Around the country in cities and towns, recruiting tents appeared inviting men to 'Come in and Enlist!'
A tent in Union Square, New York had the large blue letters 'Remember the Maine' on the wall. Outside, a veteran
was heard announcing: 'Step up, gentlemen, and enroll! All between the ages of eighteen and forty-five can go
to help free Cuba. Remember the Maine! Now is the time to step into the ranks and defend the country from
the Spaniard. We have a hero for a Colonel and we want only heroes. No coward need apply. You'll be well
treated by your Colonel, you'll get $15.60 a month, your clothes and your grub, and you'll have a chance to fight
for free Cuba. Step up and enroll. This is not a draft. There's no bounty in this war! We want volunteers to
fight the Spaniards!' Those that did apply were given a full physical examination by surgeons.

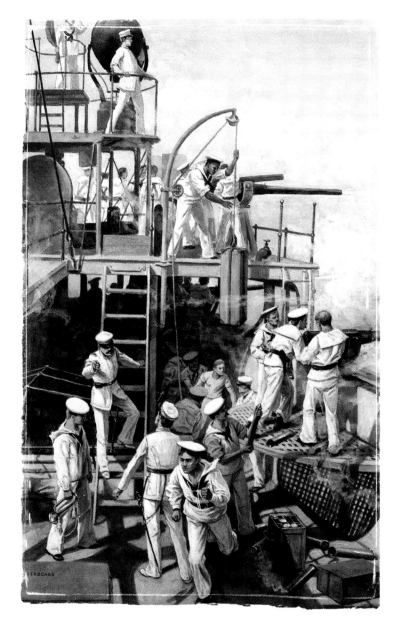

RUFUS ZOGBAUM

Winter Manoevres North Atlantic Fleet, 1897: Working Rapid Fire Guns

◆

Gouache 14 x 22 in. (35.5 x 55.9 cm.)
Jean S. and Frederic A. Sharf Collection

Signed and dated (bl): *R. F. Zogbaum '97*

The picture probably illustrated the last large naval exercise prior to actual war, which occurred
in February, 1897 when exercises were conducted 25 miles off the coast of Charleston, South Carolina.
The North Atlantic Squadron was based in Hampton Roads, Virginia, and it was accustomed to realistic
maneuvers off the coast of Virginia. It had not used Florida for several years for fear of provoking Spain.

It is unclear where the picture was reproduced. It was intended to illustrate the progress of the "New Navy"
which the American public was hungry to learn more about. However, the image was re-used in
several war books to depict the naval battle at Santiago. In *The Story of our Wonderful Victories...*
(Philadelphia, American Book and Bible House, 1899) it was entitled *Working rapid-fire guns in the Great
Naval Battle of Santiago*; while in Murat Halstead's *Our Country in War and Relations with All Nations*
(United Subscription Book Publishers, 1898), the caption read *On board the "Brooklyn" at Santiago*.

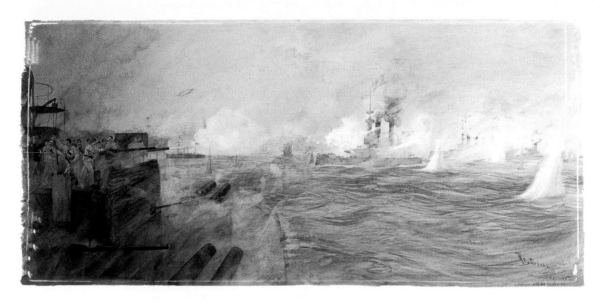

HENRY REUTERDAHL

First attack by Admiral Sampson on San Juan, Porto Rico, May 12

Watercolor and gouache on paper 18 x 34 in. (45.7 x 86.3cm.)
Jean S. and Frederic A. Sharf Collection

Signed and inscribed (br): *Reuterdahl Key West*

Published in *Truth* No. 586, July 13, 1898.

The U.S. Navy thought that Admiral Cervera would head for San Juan and hoped to catch him there. May 12th
was the day they expected to find the Spanish fleet in the harbor, but at daybreak it was obvious that
Cervera's fleet was not there, so Sampson decided to bombard San Juan in order to give his fleet practice!

The picture was drawn by Reuterdahl in Key West, Florida, from his on-site sketch. The notice in *Truth*
went as follows: '*Truth's* cartoon this week represents in glowing colors the terrific bombardment of San Juan,
the fortified capital of Porto Rico, by the American fleet under Admiral Sampson. *Truth's* artist,
Mr. Reuterdahl, whose ship pictures are easily first among all other present war painters, is at the front,
and what he transfers to the painted page is as nearly as may be the actual scenes of thundering guns
and ships in evolution; of trembling shores and troubled waters; of blood and battle, and these
great pictures will go into and become part of the history of our war with Spain.'

In the picture, the "Iowa" is firing on San Juan, while the "Indiana", the flagship "New York", and the "Amphrite"
stand by for their turn. Reuterdahl covered this engagement aboard the "Iowa"; later he traveled on the
torpedo boat "Ericsson" and the auxiliary cruiser "St. Paul", but was forced by illness to go back to Key West.

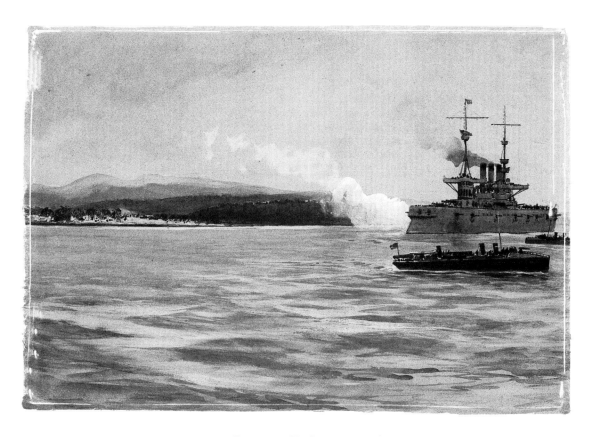

CARLTON T. CHAPMAN

The "New York" firing on a Coast-Guard of Cavalry, off Cabañas, Friday April 29, 1898

Gouache on paper 16 3/4 x 23 1/4 in. (42.5 x 59 cm.)
Jean S. and Frederic A. Sharf Collection

Published in *Harper's Weekly,* May 14, 1898, page 461,
and as a colored frontispiece to Volume 17 of *Harper's Pictorial History of the War* (1899).

Chapman was assigned by *Harper's* to the North Atlantic Squadron based at Key West, along with
Rufus Zogbaum. On April 22, the blockading squadron left Key West and was in blockade position by April 23.
Six days later, the "New York", in one of the hilarious incidents of the war, fired some shells at a party of
Spanish cavalry who had fired their rifles at the ship! Also in the picture are the "Porter" and the "Ericsson".
The New York *Herald* correspondent who witnessed the event from the "Sommers N. Smith" cabled his
report from Key West the following day: 'The flagship New York reconnoitering down the Cuban coast
yesterday evening, fell afoul of a company of Spanish soldiers, who saw fit to fire a futile volley
at the big cruiser as she swung lazily past the little harbor of Cabañas.'

Chapman stayed with Sampson's fleet throughout the entire war and sent back written dispatches
as well as drawings for publication. Both Chapman and Russell depicted this event.

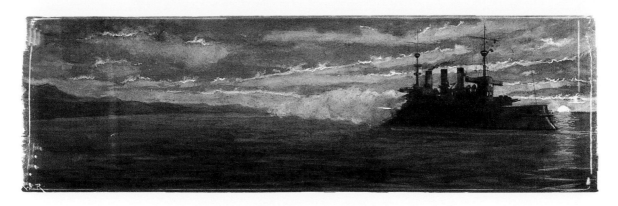

WALTER RUSSELL

Firing at cavalry on the shore near Cabañas just at sunset

Gouache on board 6 x 19 in. (15.2 x 48.3 cm.)
Jean S. and Frederic A. Sharf Collection

Published in *Century Magazine* Vol. LVI, No. 5, September 1898, page 657.

Russell boarded the dispatch-boat "Sommers N. Smith" on the afternoon of Thursday, April 21, 1898
at Key West, armed with his 'half-packed luggage, three cameras, and nine half-gallon bottles of a popular
spring water'. The boat and four others sailed out to join the fleet and accompanied Sampson's
squadron throughout the blockade of Cuba. The artist witnessed the capture of the "Buena Ventura",
the bombardment of Matanzas, and the incident depicted in this drawing.

According to Russell's account a troop of cavalry was seen near Cabañas by the "New York", and fired
upon until the last man had disappeared over the brow of the hill. 'This picture was too beautiful for death
and destruction. The sky and water were purple and gold. The "New York" herself had an ethereal aspect,
as though it were a concentration of mist floated in a body between sea and sky, rather than upon the sea.
The sun sank blood-red, apparently twice its usual size, into this molten sea, which blackened almost
immediately afterward. Then 't was night - night without the twilight which we in the North love so much.'

Carlton Chapman also depicted this scene.

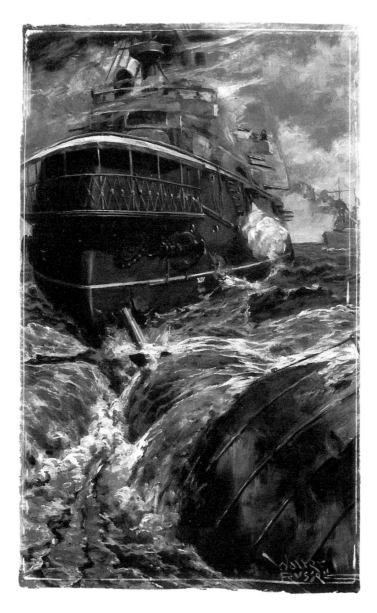

WALTER RUSSEL

An incident in the blockade

Gouache on board 16 x 10 in. (40.6 x 25.4 cm.)
Jean S. and Frederic A. Sharf Collection

Signed (br): *Walter Russell*

On May 4, 1898, Admiral Sampson embarked from the blockade with a group of warships bound for Porto Rico.
He had included among his fleet one torpedo boat, the "Porter" and two monitors, the "Amphrite" and the "Terror."
On Friday evening, May 6, the flagship "New York" was required to have in tow both the "Porter" and the "Terror".

W. A. M. Goode, in his account entitled *With Sampson through the War*, indicates that on May 7, the cable connecting
the "Terror" to the "New York" snapped, forcing the squadron to halt while new cables were connected.
The sea was rough and at the time the cables snapped it made a terrific noise and caused the "New York"
to shake. Russell appears to have drawn the incident which Goode described. Ahead of the "New York"
is steaming the "Iowa" and one can see the front end of the "Porter" which is still in tow.

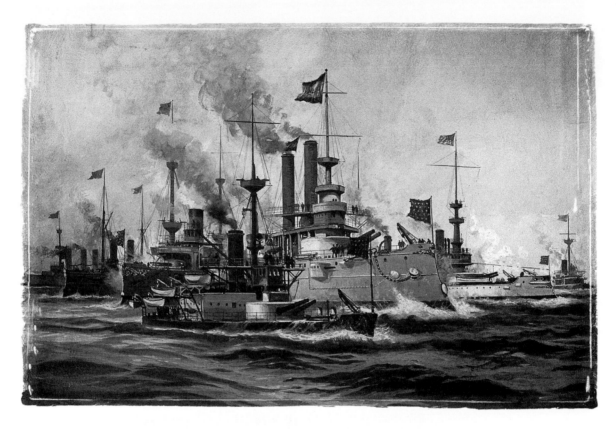

CHARLES JOHN DE LACY

*The Spanish American War: Vessels of the United States
North Atlantic Squadron which bombarded San Juan, Capital of Porto Rico,
on May 12, under Command of Rear-Admiral Sampson*

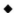

Grisaille on board 16 1/2 x 24 in. (42 x 61 cm.)
Jean S. and Frederic A. Sharf Collection

Signed (bl): *Charles J. de Lacy*

Published in the *Illustrated London News*, May 21, 1898, page 747.

The operations of the U.S. Navy during the war were observed by ships of the Royal Navy
and photographs were obtained by the *News* for use by its staff artists such as De Lacy. He obviously
had access to actual photographs of the American ships, since he accurately portrayed the
distinctive features of the ships which are identified in the reproduced illustration.

The ships in the picture were all part of the North Atlantic Squadron but not all were actually
involved in the San Juan bombardment. A companion picture on the opposite page of the *News*
showed vessels of the Spanish Squadron also drawn by the artist.

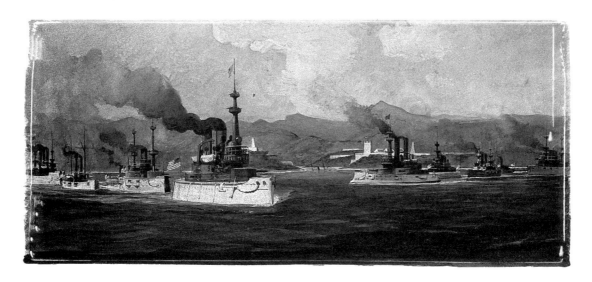

AMEDÉE FORESTIER

The Harbour of Santiago De Cuba, showing Admiral Sampson's Fleet

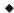

Grisaille on paper 6 x 14 in. (15.3 x 35.6 cm.)
Jean S. and Frederic A. Sharf Collection

Signed (bl): *A. Forestier*

Published in the *Illustrated London News*, July 9, 1898, page 46, 'from a sketch by a Correspondent.'

While Seppings Wright supplied the *Illustrated London News* with the majority of its Cuban war pictures, sketches were submitted by unofficial artists. Indeed, several pictures relating to the naval campaign were based on sketches or photographs supplied by members of the Royal Navy observing the operations. This particular image was used to illustrate the account of the battles around Santiago and Admiral Sampson's victory, but assuming that it took about four weeks before the pictures were reproduced, it probably depicts events relating to the blockade in early June.

The ships in this scene, which probably relates to the blockade in early June, are identified
from left to right as the "Brooklyn", "Marblehead", "Suwanee", "Texas", "Massachusetts",
"Iowa", "Oregon", "New Orleans", "Yankee", and "New York".

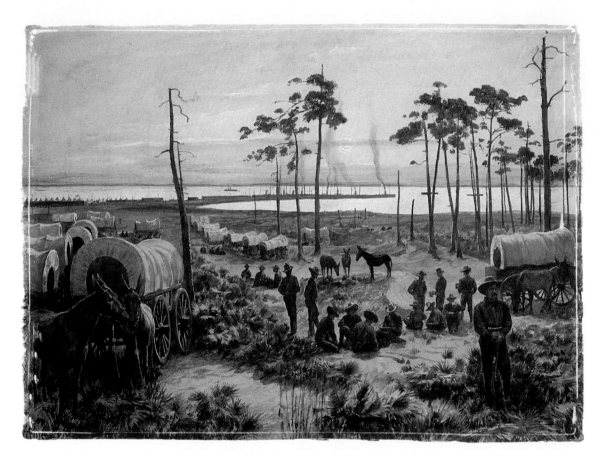

AMEDÉE FORESTIER
(FROM A DRAWING BY H.C. SEPPINGS WRIGHT)

The United States Camp at Tampa Harbour

◆

Grisaille on paper 10 x 14 in. (25.4 x 35.6 cm.)
Jean S. and Frederic A. Sharf Collection

Published in the *Illustrated London News,* June 25, 1898, page 937
'from a sketch by our Special Artist, Mr. H. C. Seppings Wright.'

By the end of May 1898, there were 16,482 enlisted men and 1,061 officers encamped at Tampa ready
for the invasion. Correspondents described them as some of the finest soldiers in the world, but one, Poulteney
Bigelow, criticized the government for choosing such an unhealthy spot as Tampa as the point of embarkation,
and for not equipping the army with food and clothing for a tropical campaign. The government fired back
that having the troops in this environment helped to condition them for the campaign in Cuba.

Following Wright's escapade on Cuba with Scovel at the beginning of May, the artist returned to
Key West. He had been in Florida since late April covering the army assembling at Tampa and his first
pictures appeared in the weekly on May 14. Pictures of the naval incidents suggest that Wright
accompanied the blockading fleet before going to Cuba with the army.

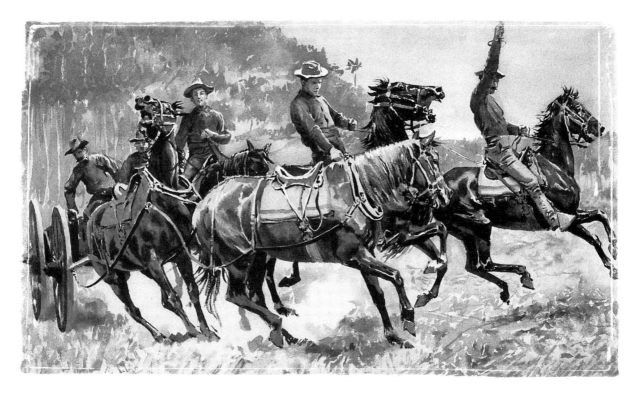

MAX F. KLEPPER

Light-Artillery Drill of U.S. Regulars at Port Tampa, Florida - "Halt!"

◆

Ink on paper 9 1/2 x 15 in. (21.6 x 38.1 cm.)
Jean S. and Frederic A. Sharf Collection

Published in *Harper's Weekly,* May 28, 1898, page 512.

On May 1, the field artillery was moved from Chickamauga where it was mobilized, to a camp adjoining
the railroad at Port Tampa, where ten light batteries were organized into a provisional brigade.
In the weeks leading up to embarkation, time was spent in acquiring new recruits, materials
and animals to equip the batteries for the campaign, and in training.

This was one of three scenes by Klepper published on the same page of *Harper's Weekly*.
The other scenes were entitled 'Gallop; March!' and 'Loading and Firing.'
The artist based them on photographs by *Harper's* Special Photographer, James Burton.

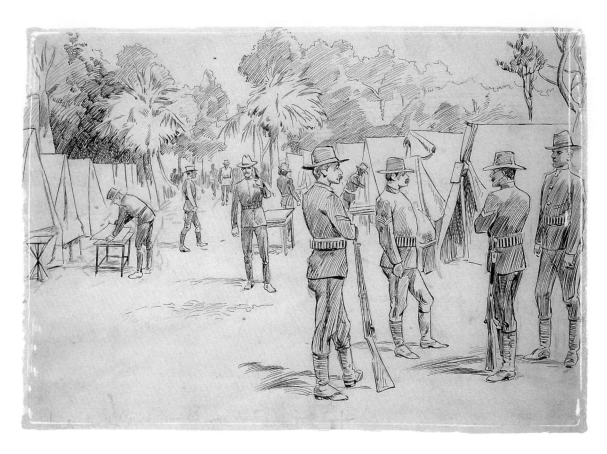

DOUGLAS MACPHERSON

Waiting to Invade Cuba: Scenes at Tampa with the U.S. Army:
Waiting for the Guard Mount, 5th Infantry at Picnic Island

◆

Ink drawing on paper 7 1/4 x 9 1/2 in. (18 x 24 cm.)
Anne S. K. Brown Military Collection (U0 1898 mf-1a)

Published in *The Daily Graphic*, May 17, 1898.

Picnic Island was located at Port Tampa, and was the camp site for a regular infantry regiment.
It was probably one of the very first camps fully functional, and thus Macpherson was able to
visit there soon after his arrival in Tampa. The correspondents visited many of the camp sites
scattered around the town as there was no one site large enough to accommodate the
entire 5th Army. Some regiments were camped as far as 40 miles away at Lakeland.

Macpherson's reports from Tampa began to appear in *The Daily Graphic* in May
following a two week delay from the date of report to date of actual publication.

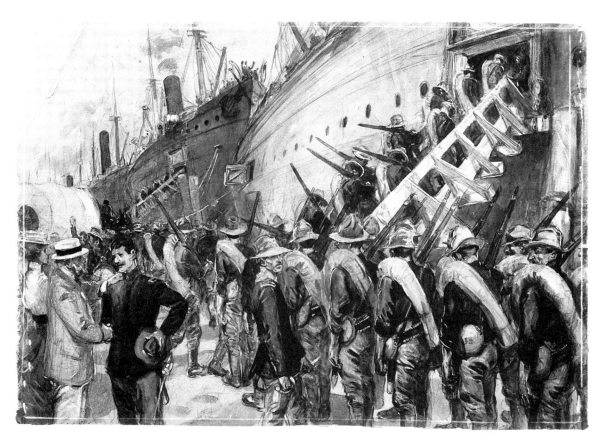

WILLIAM GLACKENS

The starting of General Shafter's Expedition to Santiago de Cuba:
American troops boarding transports at Port Tampa, June 7, 1898

Gouache 16 x 22 in. (40.6 x 55.9 cm.)
Jean S. and Frederic A. Sharf Collection

Published in *Munsey's Magazine* Vol. XX, No. 6, (March 1899), page 897,
to illustrate an article by Richard H. Titherington entitled 'Our War with Spain'.

In Tampa, Glackens met Stephen Bonsal, the news correspondent, and began creating 'illustrations
telling of the departure, voyage and arrival, and subsequent work and, fights of the U.S. troops in Cuba.'
At Port Tampa, the artist sketched the troops boarding the transports amidst confusion, although this picture
presents an orderly appearance. For several days, the long slip at Port Tampa was thronged with soldiers,
and piled up with munitions of war, women saying farewells to their loved ones, mules, and guns.

Bonsal described his arrival at the wharf: 'By dawn, in army wagons, muleback, and on foot,
we reached the long dock and went out to our respective transports, where, crowded like sardines
and almost suffocated by the prevailing heat, the soldiers were watching and waiting for the start,
and cheering to the echo of every indication of an early departure.'

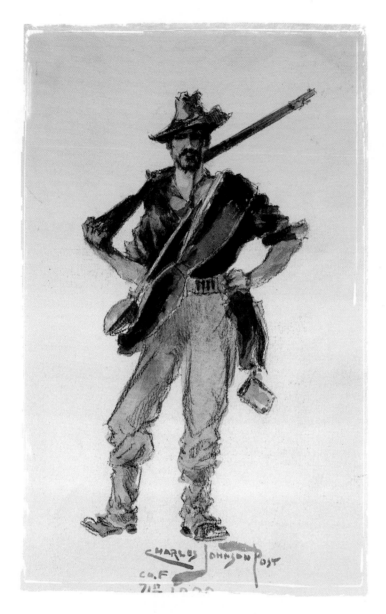

CHARLES JOHNSON POST

Portrait of the artist in uniform

◆

Watercolor on paper 9 1/2 x 6 1/2 in. (24.2 x 16.5 cm.)
Anne S. K. Brown Military Collection (Todd Collection)

Inscribed: *Charles Johnson Post Co. F 71st 1898*

This self-portrait is almost identical to one in the Army Art Collection which Post sketched in Cuba in July 1898.
Yet another variant of this picture bears the notation "after sketch by Jimmy Lowe, Santiago, Cuba, July 31 - 1898."
Post carried two sketchbooks throughout the Santiago campaign and it was from these and a keen visual
memory that he was able to create a series of paintings chronicling his experiences and those of his regiment,
the 71st New York Volunteers. Macpherson wrote that, with the exception of the Rough Riders and
one or two companies of the 71st New York, the volunteers were ill-disciplined and badly officered.

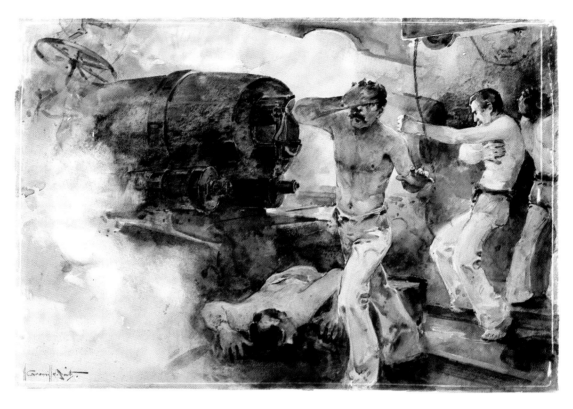

WALTER GRANVILLE-SMITH

Explosion below Deck

◆

Wash drawing on board 11 x 17 in. (28 x 43.2 cm.)
Jean S. and Frederic A. Sharf Collection

Signed (bl): *W. Granville-Smith*

This scene probably represents the shelling of the battleship "Texas". During the landing of the army at Daiquiri
on June 22, the ship was assigned to shell the western batteries at the entrance to Santiago harbor. A 6-inch shell
from one of the Spanish batteries hit the "Texas" below deck where there were six 6-pounder guns, three on each side.
The crews of all these guns were at their quarters when the projectile hit killing one man and wounding eight.

The war lasted three and one half months and in that time the navy fought two major engagements, enforced
a blockade and was involved in several smaller incidents. Yet, it lost only 12 sailors killed, and 10 wounded.

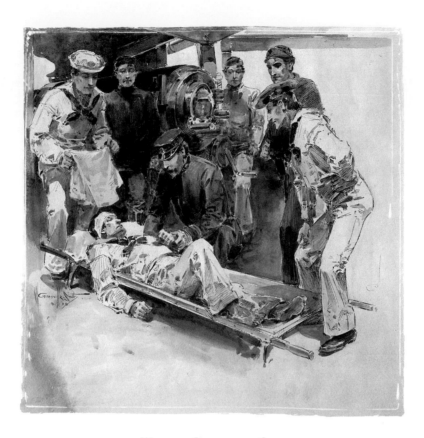

WALTER GRANVILLE-SMITH

A Wounded Sailor

◆

Wash drawing on board 11 x 17 1/2 in. (28 x 44.5 cm.)
Jean S. and Frederic A. Sharf Collection

Signed and dated (bl): *W. Granville Smith 1898*

No title on reverse but the following notation:
Show proof to Artist for Cutting Instructions. Reproduce exact in Every Particular.
Reduce to 6 1/2" - 133 Line Screen. Submit Rough Proof June 9 I 3177 - June 11

Three gunners stand by the breech of a large naval gun; two sailors administer to a wounded
colleague lying on a stretcher. A ship's doctor is taking the pulse of the sailor. This scene may also relate
to the shell which hit the "Texas" (see No. 31). It is not known where this picture was published.

The wounded from the "Texas" were transferred to the "Solace", one of several hospital ships which
accompanied the fleet, and Carlton Chapman recalled the scene: "When the poor fellow who was so badly burned
was being bandaged up he asked the doctor, in a faint voice, "Was that a Dago shell or a premature explosion,
doctor?" When told that it was a Dago shell, he said "Then its all right." On an earlier voyage back to the States,
the "Solace" carried fifty-four men from naval ships, six of them from wounds received in battle. One casualty
was a victim of 'friendly fire' when a shell from another American ship exploded directly above the "Iowa"
during the bombardment of San Juan, Porto Rico in May, 1898. Another was struck by a bullet aboard the
"New York" when a revolver dropped from the belt of a sailor and exploded. Other men were suffering
from fractured limbs resulting from shipboard accidents while four were afflicted with consumption.

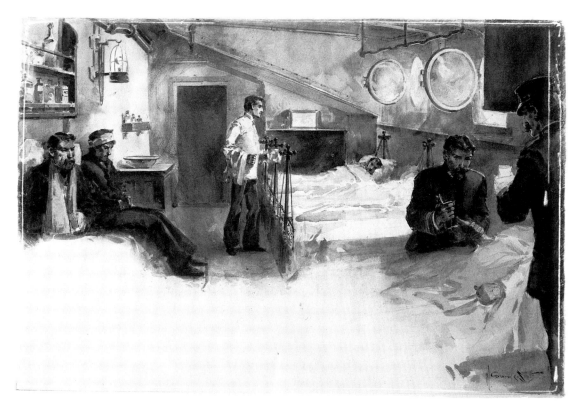

WALTER GRANVILLE-SMITH

The Ship's Hospital

◆

Wash drawing on board 11 x 17 1/2 in. (28 x 44.5 cm.)
Jean S. and Frederic A. Sharf Collection

Signed (br): *W. Granville-Smith*

No title on reverse but the the following notation:
Boston Engraving Co - 50 Hartford St - Boston. Want Plate on Fri...

On the left is a dispensary with two wounded sailors sitting beneath a shelf holding medicine. On the right are four beds with two foreground figures administering last rites to an unseen sailor whose bed and hands are visible. This may be intended to represent the "Iowa" or one of several hospital ships which accompanied the U.S. fleet. The "Solace" had a full operating room and bunks for patients; another ship, the "Relief", was described as being 'fully equipped with a skilled corps of nurses and all modern surgical appliances and equipment for the treatment of sick and wounded.'

In contrast to the navy's preparations for the wounded, the army had deplorable arrangements at the front. As Stephen Bonsal stated: 'At least one-third of the men wounded on July 1st received no attention, and were not brought back to the division hospital until the afternoon of July 3rd.' He described the treatment of American wounded as 'outrageous.' Some soldiers were fortunate to be treated on the hospital ships.

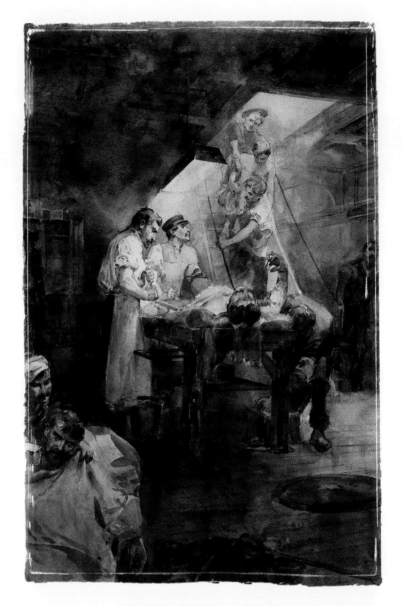

WALTER GRANVILLE-SMITH

*A tense moment - Dr. Crandall, surgeon on the "Iowa", operating on a
Spanish sailor after the Battle of Santiago Bay, Sunday, July 3, 1898*

◆

Watercolor on board 20 x 14 in. (50.8 x 35.5 cm.)
Jean S. and Frederic A. Sharf Collection

Signed and dated (br): *W. Granville-Smith '8 '98*

Following the battle of Santiago Bay, Spanish prisoners including 160 wounded seamen from the "Vizcaya"
were transferred to the "Iowa". According to a newspaper account in the New York *Herald*, many of the wounded
were 'fearfully mangled'. Surgeon Rand Crandall of the "Iowa" 'took charge of the maimed, dressed their wounds
and did all that was possible to alleviate pain.' Admiral Cervera was so touched by the humanity of Crandall that
he gave him his autograph, saying simply that 'he had no other souvenir to offer, he, too, having lost "all but honor."'

A drawing by C. D. Graves of a similar scene appeared on the cover of *Collier's Weekly*, July 16, 1898.
It was based on a photograph taken on board the "Iowa".

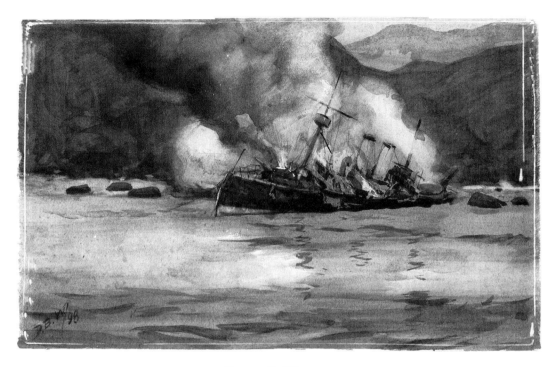

DAVID B. WATERS
After The Battle of Santiago: The Total Destruction of Admiral Cervera's Fleet - The "Almirante Oquendo"

◆

Gouache on Board 9 x 12 in. (23 x 33 cm.)
Jean S. and Frederic A. Sharf Collection

Signed in lower left: D.B.W. '98

Published on page 151 of *The Graphic*, July 30, 1898.

On Sunday, July 3, 1898, the Spanish Squadron under Admiral Cervera emerged from the harbor
of Santiago de Cuba at 9:35 am. Four cruisers and two destroyers were attempting to escape
from the American blockade by outracing the Americans in the open ocean.

The Spanish Flagship "Infants Maria Teresa" lead the formation as it exited through the narrow channel
which accessed the harbor at Santiago; three cruisers ("Vizcaya", "Cristobal Colon", and "Almirante Oquendo")
and two destroyers ("Pluto" and "Furor") followed. By 10:00 am the Spanish Squadron was out in the open.

Immediately, as each ship emerged from the channel, they were subjected to punishing firepower from the
American fleet. The two destroyers were ablaze at once, and abandoned; by 10:15 am the "Infanta Maria Teresa"
was beached at Nima Nima, 6 1/2 miles from the entrance to Santiago harbor, and at 10:30 am the
"Almirante Oquendo" was beached one half mile further at Juan Gonzales.

The "Vizcaya" managed to get as far as Aserraderos, 15 miles from Santiago, before being forced to abandon
ship at 11:15 am. The "Cristobal Colon" was the fastest ship of the squadron, and stood the best chance to escape;
but at 1:10 pm even this ship was forced to give up beaching itself at Rio Torquino, 48 miles from Santiago. Thus,
the Battle of Santiago ended, but all four cruisers remained visible, partially submerged, along the coast of Cuba.

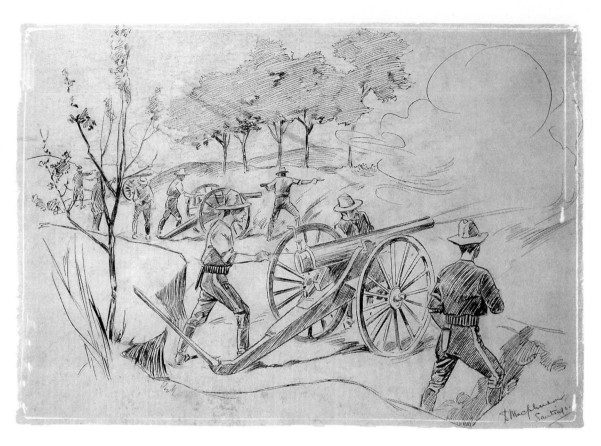

DOUGLAS MACPHERSON

The bombardment of Santiago: Captain Capron's Battery in action

◆

Ink drawing on paper 7 x 9 1/2 in. (18 x 24 cm.)
Anne S. K. Brown Military Collection (U0 1898 sf-1)

Signed and inscribed (br): *D. Macpherson Santiago*

Published in *The Daily Graphic,* Tuesday, August 9, 1898, page 4.

As there were insufficient transports to carry the entire artillery brigade to Cuba, only four batteries
accompanied the initial expedition. Generally known by the name of the commander rather
than their official designation, they were Capron's, Best's Grimes' and Parkhurst's.

The accompanying note by Macpherson in *The Daily Graphic* stated: 'A bombardment was commenced
at 4:00 pm on Sunday, the 10th of July. It was a splendid, spectacular scene, and one was able to sit comfortably
on a hill and watch it with almost as much ease as if it had been at an Earl's Court Exhibition.' Later however, the
artist wrote that the artillery at the front was totally inadequate for the effectual bombardment of Santiago, and had
been outclassed by the Spanish artillery which had smokeless powder and every position under perfect range.

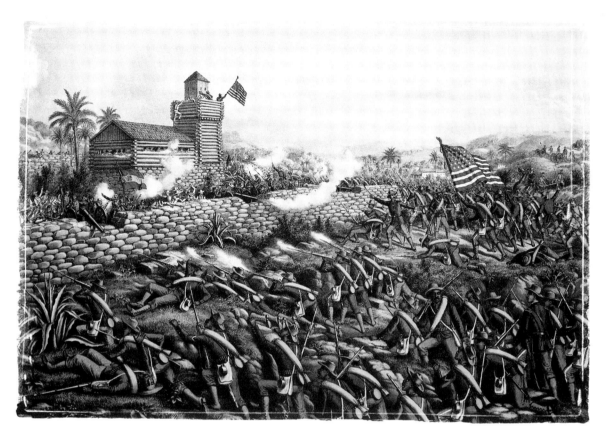

KURZ & ALLISON

*Charge of the 24th and 25th Colored Infantry and Rescue
of Rough Riders at San Juan Hill, July 2nd, 1898*

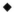

Chromolithograph 20 x 28 in. (51 x 71 cm.)
Anne S. K. Brown Military Collection

Published by Kurz & Allison, 267-269 Wabash Ave, Chicago, 1899

A popular print typical of the period but completely imaginary. Nonetheless, such
pictures added to the mythology surrounding the Rough Riders at San Juan. The print
does recognize the contribution of the African-American regiments in the war, however.

One writer, John Sloan, described William Glackens seeing the Rough Riders stuck at the foot of
San Juan Hill after being repulsed. It was not until an African-American regiment went up that the
Rough Riders followed. Glackens apparently shouted 'cowards' at the Rough Riders. Certainly the
24th Colored Infantry at San Juan, and the 25th at El Caney, played a major role in the successes of July 1.
The New York *Herald* described the moment at San Juan: 'Finally orders were given to charge the fort,
and the Twelfth and 25th infantry regiments undertook the difficult task. They formed behind a
clump of trees four hundred yards from the fort and advanced in open order. They gave a cheer as
they broke from cover and began to run up the precipitous ascent. The Spanish opened a fierce fire
and many men fell, but the regiments kept on. When our men were within fifty yards of the
fort the Spaniards gave way and fled down the hill into the village.'

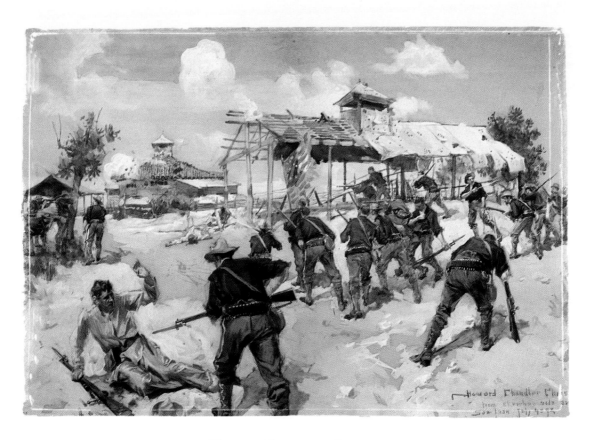

HOWARD CHANDLER CHRISTY

The Supreme Moment before Santiago

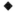

Watercolor on board 18 x 27 in. (45.7 x 68.6 cm.)
Jean S. and Frederic A. Sharf Collection

Signed and inscribed (br): *Howard Chandler Christy from sketches made at San Juan, July 4, 1898.*
Copyright, 1898, by Truth Co.

Published in *Truth* No. 595, September 14, 1898, and in W. Nephew King,
Story of the Spanish-American War (New York, *Collier's*, 1898)

Depicts the 71st Regiment, the Rough Riders and other troops routing the Spaniards at the Block House
on San Juan Hill. Christy, who witnessed the scene described it as follows: 'The capture of the blockhouse
at San Juan was a wonderful sight. Twelve or thirteen men advanced beyond the main line. They halted at the
brow of the hill directly in front of the Spanish entrenchments, and opened fire on the enemy. In a few minutes
they were joined by the main line, and they dashed almost into the entrenchments and over them. Then the
charge on the blockhouse itself was made...The place was alive with regulars and in a few minutes the
Spaniards were driven back and the Stars and Stripes waved over the Spanish stronghold.'

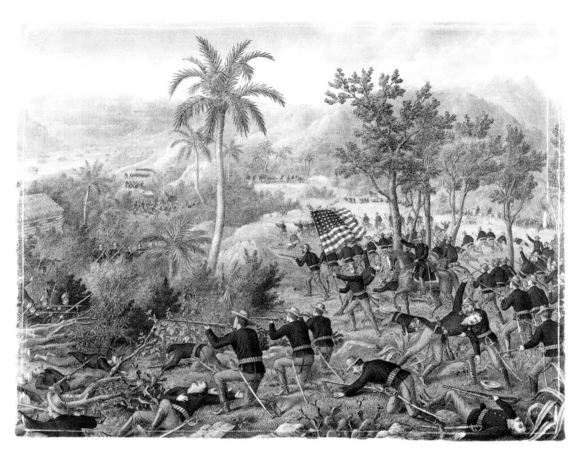

KURZ & ALLISON

Battle of La Quasina near Santiago de Cuba, June 24, 1898 (Gen. YoungComg.)
Rough Riders, 1st & 10th Reg. Cavalry (About 1000) Routed 2000 Spaniards
(who were in Ambush) with heavy loss. AM: 18 Killed, 60 wounded, 9 missing.

◆

Chromolithograph 20 x 28 in. (51 x 71 cm.)
Anne S. K. Brown Military Collection (UB 1898 gf-1)

Published by Kurz & Allison, 267-269 Wabash Ave, Chicago, 1898; reproduced in
Exciting Experiences in Our Wars with Spain and the Filipinos edited by Marshall Everett
(Chicago, The Educational Co., 1900), page 311 as 'American Assault on Blockhouse
and Entrenchments near El Canny'; and in *The Story of Our Wonderful Victories...*
(Philadelphia, American Book and Bible House, 1899) as 'Battle of San Juan, near Santiago, Cuba.'

The event depicted is actually the skirmish at Las Guasimas. Here the Spanish
chose to defend a gap through the hills leading to Santiago. In a fierce fight,
the American force under General Wheeler forced the Spanish to withdraw.

The newspapers made a great deal over the action, particularly the role of the Teddy Roosevelt's eight
troops of Rough Riders and the victory over a superior force. Las Guasimas also produced the first
notable casualties of the campaign, the deaths of Captain Allyn Capron and Sergeant Hamilton Fish, Jr.,
and the press was quick to immortalize these men with portraits and epitaphs.

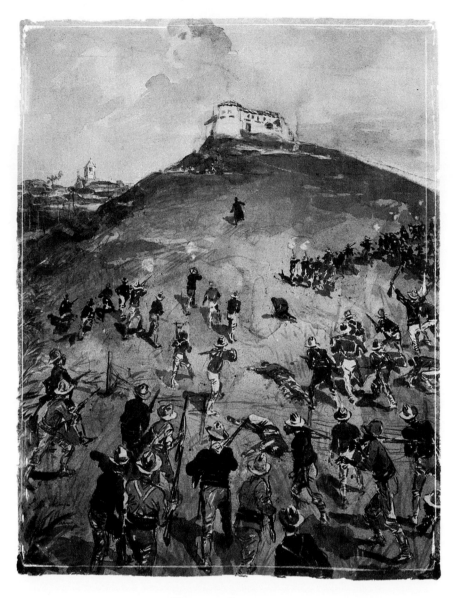

WILLIAM GLACKENS

The Twelfth and Twenty-Fifth Infantry taking the blockhouse at El Caney, July 1st

◆

Gouache 13 1/4 x 17 in. (33.7 x 43.2 cm.)
Jean S. and Frederic A. Sharf Collection

Published in *McClures Magazine* Vol. XI, No. 5 (September 1898),
page 508, in Stephen Bonsal's article 'The Fight for Santiago'.

Glackens witnessed this attack on the stone fort of El Viso which stood outside the town of El Caney. The church of El Caney can be seen in the left distance. It is unclear who the lone figure ahead of the main line is. According to John Black Atkins' account *The War in Cuba,* "an American captain strode up the slope in front of his men. The figure stood out all alone; it was clothed in a long cloak that looked like a macintosh. He went on and on without stopping til he could peer into the trenches and the fort; then he wheeled suddenly round and ran back down the hill..."

However, James Creelman of the New York *Journal* also claimed to have been the loan figure who ran up the hill in the hope of capturing the Spanish flag! He wrote '...and when I found myself actually out on the clear escarped slope leading up to the trench where even a mouse could not hide itself I walked fast... Gradually I got away from our line, so that by the time I was within twenty feet of the barbed wire fence I was at least two hundred feet ahead of Captain Haskell and his men. I was absolutely alone.'

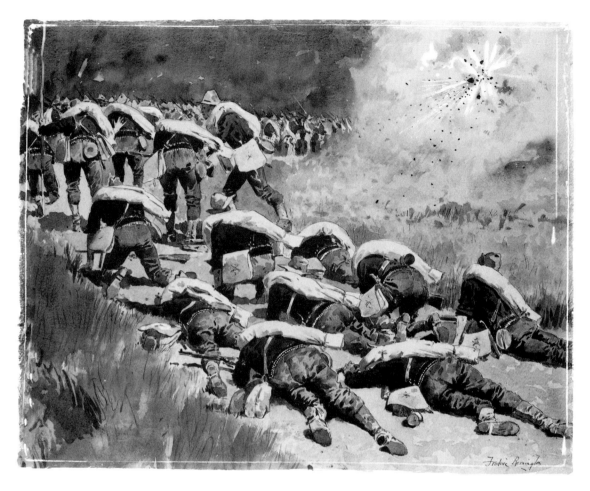

FREDERIC REMINGTON

Shrapnel coming down the road. Soldiers lying down in front of it
(Artful dodgers: Soldiers dodging shrapnel)

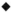

Pen and black ink and brush, heightened with white
gouache on board 21 7/8 x 28 in. (55.5 x 71.1 cm.)
The Art Institute of Chicago: George F. Harding Collection (1982.1580)

Signed (br): *Frederic Remington*

Published in New York *Journal* and *Advertiser*, August 14, 1898.

The road to Santiago was treacherous as the Spaniards had estimated the range for their guns.
One shell burst over the Rough Riders and forced many of the foreign attachés and correspondents
to flee the scene. As Remington described it: 'The next shell went into the battery killing and doing damage.
Following shell (sic) were going into the helpless troops down in the road.' At another spot, 'Bloody Bend'
or 'Bloody Angle', Remington witnessed many American soldiers being hit with shrapnel, and he himself
narrowly escaped being hit by a Mauser bullet. 'I dropped in the tall guinea grass and crawled to the soldiers,
and they studied the mango trees; but could see nothing. I think that episode cost me my sketchbook.'

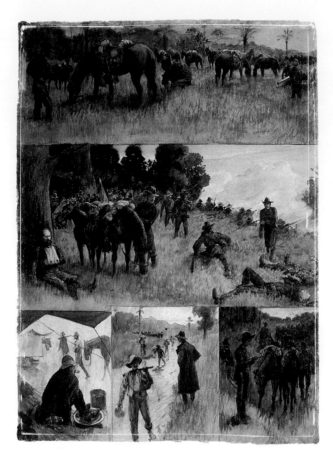

AMEDÉE FORESTIER
(FROM A DRAWING BY H. C. SEPPINGS WRIGHT)

Before the Battle of San Juan

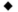

Grisaille on paper 14 x 10 in. (35.6 x 25.4 cm.)
Jean S. and Frederic A. Sharf Collection

Signed (bl): *A. Forestier*

Published in the *Illustrated London News*, August 13, 1898, page 233,
'from sketches by our Special Artist, Mr. H. C. Seppings Wright.'

Wright covered the mobilization at Tampa and crossed over to Cuba on the troop ship "Berkshire" in mid June.
He observed the fighting around San Juan and Kettle Hill from a position near the guns. A shell landed
close by wounding his horse which darted off 'taking with him my saddle-bags, sketches, books, stamps,
and everything I had except what I happened to have in hand.' The numerous pictures in the *Illustrated
London News* suggest that he was present throughout the whole campaign, and his last picture
of the war was published on August 27 by which time he was back in London.

While a few of Wright's sketches were reproduced as facsimiles in the *News*, the majority were re-drawn
by staff artists such as Forestier. This composite picture depicts five scenes: 1. The Cavalry Squadron ready
to start, 10:30 pm; 2. Under Fire: A Hot Corner; 3. A Field-Philosopher: Our Artist protecting his sketches;
4. A Cuban Contingent on the March; 5. The Battery ordered to the Front: A Cigarette by the way.

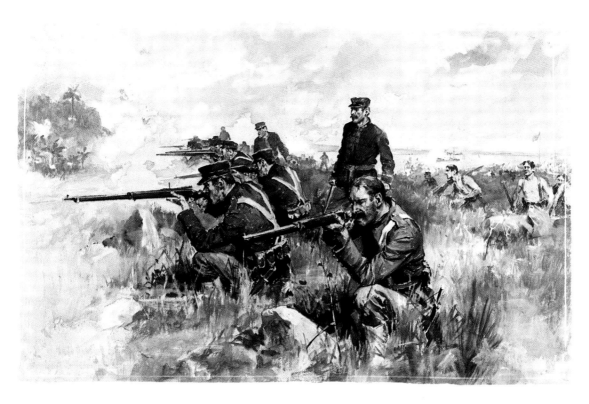

FREDERIC COFFEY YOHN

The Fight at Guatanamo: Marines under
Lieutenant Colonel Huntingdon repelling an attack.

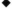

Gouache on board 14 x 22 in. (35.6 x 55.9 cm.)
Jean S. and Frederic A. Sharf Collection

Inscribed (bl): *To My Friend Hutchison Scott - F. C. Yohn*

Published in *Colliers Weekly,* June 25, 1898, pages 12-13.

On June 10, 1898, 650 men of the First Marine Division landed at Guantanamo Bay to establish
a coaling station for the blockading ships. The Spanish attack on the following day caught the marines
completely by surprise. Many were swimming or bathing, and rushed to their posts with little or
no clothing. Pinned down by Spanish snipers, the firing continued on and off for several days.

Yohn was working as a staff artist in New York at the time so this picture must have been based on
descriptions of the action, but the artist accurately caught all the essential elements. One account of the action
appeared in the New York *Herald*: 'Col. Huntingdon, commanding the marines, formed his men in a semicircle
on the far slope of the hill, and they were ordered to kneel. In a few minutes the mountains were resounding
with the fusillades the Americans poured into the woods and bushes. There was no excitement beyond
that natural to an occasion of the sort. The men obeyed orders instantly, and there was no firing
without orders, as is generally the case when troops go into action for the first time.'

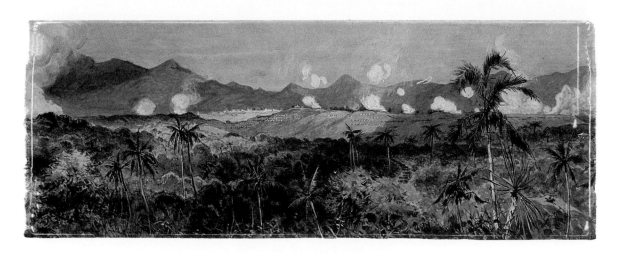

CHARLES JOSEPH STANILAND
(FROM A DRAWING BY DOUGLAS MACPHERSON)

Panoramic view of the bombardment of the town of Santiago, as seen from a neighbouring height

◆

Grisaille on paper 4 1/2 x 12 in. (11.5 x 30.5 cm.)
Jean S. and Frederic A. Sharf Collection

Signed (br): *C. J. Staniland*

Published in *The Graphic,* August 13, 1898, page 221.

The caption which accompanied the illustration was from a letter by Macpherson: 'Our Special Artist writes: 'The army has constructed magnificent trenches on the ridges of the hills around Santiago. A bombardment was begun on July 10. It was a splendid scene, and I was able to sit comfortably on a hill and watch it with almost as much ease as if I had been at an Earl's Court Exhibition. The firing continued the next day in a desultory way without any reply from the Spaniards, except a few shots from sharpshooters, until about noon, when General Shafter sent in under a flag of truce another summons for the surrender of the town.'

Anticipating a bombardment, between 12,000 and 15,000 inhabitants had fled Santiago. Those that were left suffered terribly during the siege. They were panic stricken and suffering from a severe shortage of food and medical supplies, rice being the only food available. Spanish prisoners were found to have been on half-rations and many of them were malnourished. In light of the extreme conditions, the foreign consuls in the city pressured General Toral in commanding the Spanish garrison to surrender, which he did on July 14.

WALTER GRANVILLE-SMITH

July 4th, 1898

◆

Wash drawing 11 x 7 in. (26 x 17. 8 cm.)
Jean S. and Frederic A. Sharf Collection

No title on reverse but the the following notation: *02 East 23rd Street, NY*

A Naval Officer in full summer dress standing beside a cheering lady in white dress. The uniform suggests
the period of the war and while the actual subject of the picture is unknown, it may relate to the celebrations
following the news of the naval victory at Santiago Bay on July 3, 1898. The papers referred to the victory
as a 'Fourth of July Gift.' In fact Admiral Sampson himself in his dispatch sent from Siboney on July 3
announced: 'The fleet under my command offers the nation as a Fourth of July present the destruction of
the whole of Cervera's fleet. No one escaped.' Around the country there was a massive outburst of
excitement when the news broke and in the capital it was described as the greatest Fourth of July
the city had seen since that of Gettysburg and Vicksburg thirty-five years earlier.

This picture is almost identical to another by Smith entitled 'On Shore Leave' which appeared in
Harper's Weekly, July 6, 1901. Images of patriotism and sentimentality were common throughout the war.
Howard Chandler Christy captured this theme in a picture showing an officer reading a letter
by a campfire with a vision of a young woman in a ball gown seated at his left.

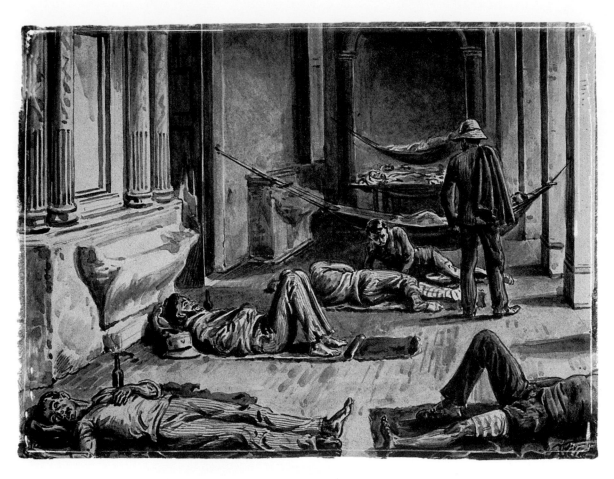

STEPHEN T. DADD
(FROM A DRAWING BY DOUGLAS MACPHERSON)

Wounded Spanish Soldiers in the Church at Caney

◆

Grisaille on paper 5 1/4 x 7 in. (13.3 x 17.8 cm.)
Jean S. and Frederic A. Sharf Collection

Signed (bl): *S. T. Dadd*

Published in *The Graphic*, August 13, 1898, page 221.

The caption in *The Graphic* reads: 'After describing the quaint old church picturesquely situated in the square at Caney, whither refugees from Santiago were flocking at the time, our Special Artist goes on to say: "The interior of the church presented a striking contrast to the brilliance of colour that lit up the scene outside. Along the crumbling aisles lay wounded Spanish soldiers, some upon old sacks, and a few in hammocks, or cots, their blue-grey uniforms harmonising with the cool gloom of the church."'

Stephen Bonsal visited the church on July 3rd and made the following observations: 'All, or almost all, the Spaniards were very seriously wounded. Many were unconscious, and others, with strange gasping cries, were but just returning to consciousness after having been etherized while undergoing operations. As I walked down the line, many a poor fellow stretched out his trembling hand, begging piteously for food and drink, a little *caldo*, or soup; but I had nothing to give them.'

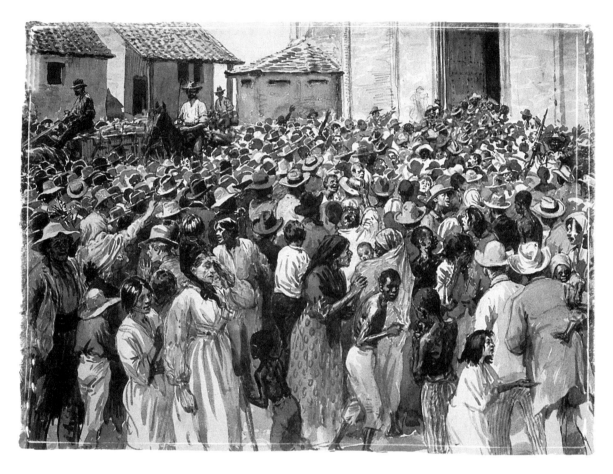

HENRY MARRIOTT PAGET
(FROM A DRAWING BY DOUGLAS MACPHERSON)

The Horrors of War: Feeding Starving Refugees from Santiago at Caney

◆

Grisaille 10 3/4 x 14 3/4 in. (27.3 x 37.5 cm.)
Jean S. and Frederic A. Sharf Collection

Initialed: *H. M. P*

Published in *The Graphic,* August 13, 1898, page 220.

A note from Macpherson was included in the caption to the picture: 'When Santiago was threatened with bombardment, refugees, old men, women and children, poured into Caney, and for some days were absolutely without food. "Things have, however, improved," our Special Artist says, "in as much as some rations are now provided - a daily allowance per head of four crackers, an onion, good or rotten as luck would have it, and a teacupful of sugar. The issue of these rations gives rise to some distressful scenes. The people stand in the market square packed as closely as possible, awaiting the distribution. When the hour is reached, the impatient crowd becomes one surging mass, striving to squeeze into the church where the food is distributed. Of course the weakest suffer. Children are crushed and trampled on, and women who have been waiting for hours are pushed aside, and are left weeping piteously. The change in the appearance of these refugees is startling. The wild, despairing look of starvation is upon their countenance, their eyes protrude, and their faces are drawn and haggard."'

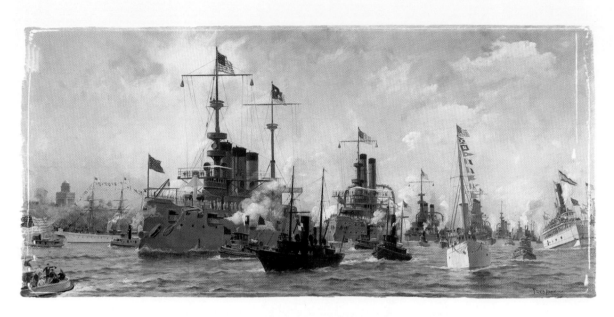

FRED PANSING

The Nation's Welcome to the Victorious Fleet.
The Fleet under Admirals Sampson and Schley saluting Grant's Tomb, August 20

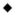

Oil on canvas 20 x 48 in. (50.8 x 121.9 cm.)
Museum of the City of New York - Gift of Dwight Franklin, 31.94.7

Signed (br): *Fred Pansing*

Published in W. Nephew King, *The Story of the War of 1898* (New York, P.F. Collier, 1898), page 313.

The North Atlantic Squadron left Cuban waters on August 14, 1898, and reached New York Harbor on the morning of the 20th. There was an enormous crowd on hand to greet them in vessels of all kinds - steamers, yachts, and tugboats. The artist has clearly captured this enthusiastic reception. After some delay, the ships formed into line for their trip up the Hudson River as far as Grant's Tomb. Crowds gathered along the river and on the rooftops to cheer the fleet.

Julian Hawthorne summed-up the moment in *Collier's Weekly* on September 3: 'On Friday, as they came on, one after one, gray champions, hardly distinguishable from the gray sea... seven champions of Christendom and of liberty: invincible, victorious, master of arms, dead-shots every one, terrors of evil doers, pride of free men and free ideas.' Hawthorne was referring to the "Oregon", "Brooklyn", "New York", "Texas", "Massachusetts", "Iowa" and "Indiana".

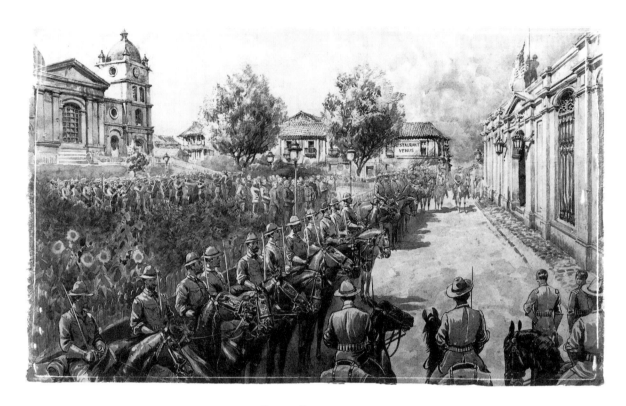

JOHN CHARLTON
(FROM A DRAWING BY DOUGLAS MACPHERSON)

*Santiago, Cuba: Hoisting the American Flag after the Surrender of the town,
17th July 1898. Col. Roosevelt's Rough Riders and Band in the Main Square*

◆

Wash drawing on paper 16 x 25 1/4 in. (40.5 x 64.2 cm.)
Anne S. K. Brown Military Collection (UO 1898 lf-1)

Published in *The Graphic*, August 20, 1898, pages 264-265; reproduced in *The Story of Our Wonderful Victories
Told by Dewey, Schley, Wheeler, and Other Heroes* (Philadelphia, American Book and Bible House, 1899); and *Exciting
Experiences in Our War with Spain and the Filipinos* edited by Marshall Everett (Chicago, The Educational Co., 1900).

A double-page drawing after a sketch by Douglas Macpherson, re-drawn by the paper's London-based artist,
John Charlton. According to the artist for *Leslie's*, Charles M. Sheldon, very few correspondents succeeded in
witnessing the surrender scene due to General Shafter imposing a ban on all journalists entering Santiago.
A few did go in and nothing was said. Shafter was obliged therefore to lift the ban and the press rushed in.

A New York paper described the scene that took place in the public square between the palace and the imposing
Catholic cathedral: 'Across the plaza was drawn up the Ninth infantry, headed by the Sixth cavalry band.
In the street facing the palace stood a picked troop of the Second cavalry with drawn sabers, under command
of Captain Brett. Massed on the stone flagging between the band and the line of horsemen were the brigade
commanders of General Shafter's division, with their staffs. On the red tiled roof of the palace stood Captain
McKittrick, Lieutenant Miley and Lieutenant Wheeler...Captain McKittrick hoisted the stars and stripes.'

Douglas Macpherson

Entry of General Shafter and his staff into Santiago, 17th July 1898

◆

Ink drawing on paper 7 1/4 x 9 1/4 in. (18.2 x 23.7 cm.)
Anne S. K. Brown Military Collection (U0 1898 mf-1b)

Published in *The Daily Graphic*, Saturday, August 13, 1898, page 5.

At 9:30 am on Sunday, July 17th, General Shafter and his staff, escorted by 100 mounted men, left his
camp to meet General Toral to sign a formal surrender. Shafter and his staff escorted by the Ninth Infantry and
the Second Cavalry then rode toward Santiago. Stephen Bonsal takes up the story: 'The streets by which the cortége
entered were barricaded in at once the most formidable and ingenious manner...Once in the heart of the city,
signs of the havoc of the siege and the ravages of war became less noticeable. The streets were almost deserted,
save for here and there groups of curious but well-behaved Spanish troops.' It would appear from this
sketch drawn on the spot that civilians with parasols also witnessed the victors as they came in.

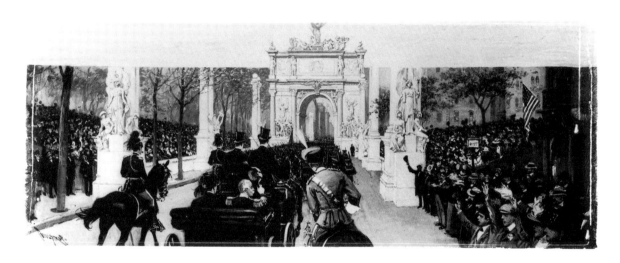

THURE DE THULSTRUP

Parade in Honor of Admiral Dewey

◆

Wash drawing on paper 13 x 37 in. (33 x 94 cm.)
Museum of the City of New York

Signed (bl): *Thulstrup*

In September 1899, Dewey returned from the Philippines aboard the "Olympia" to a tumultuous welcome in
New York. On Friday, September 29, there was a naval parade, followed the next day by a seven-mile long parade
involving over 32,000 troops, and 2500 singing schoolchildren through New York City. At the Dewey Triumphal Arch
built in Madison Square, Dewey along with Mayor Van Wyck, General Nelson Miles and Admiral Sampson, reviewed
the parade. Other events included a fireworks display, and a gun salute at Grant's tomb. Thulstrup covered these
events for *Harper's* before traveling down to Washington to record the admiral's reception in the capital on October 3.

Dewey is seen riding in an open carriage with Mayor Van Wyck along 5th Avenue with Madison Square
on the left and the Hoffman House Hotel on the right. Ahead of them is the arch. This picture was
apparently not published but a similar one by Thulstrup showing Dewey coming along Riverside Drive
in the Shore Parade appeared in *Harper's Weekly* on October 7, 1899.

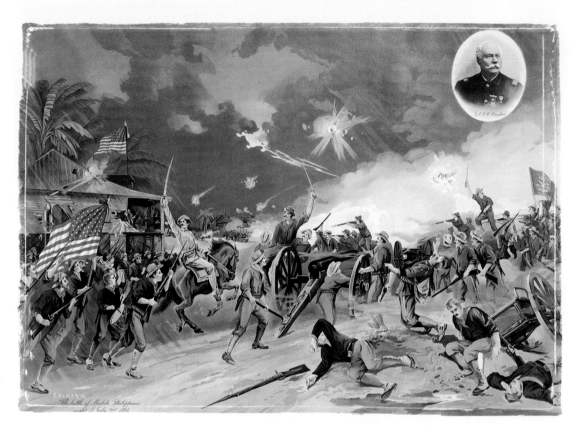

ALBERT HENKE

The battle of Malate, Philippines, night of July 31st 1898
[and inset portrait of Col. A. L. Hawkins]

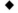

Chromolithograph 20 x 28 in. (51 x 71 cm.)
Anne S. K. Brown Military Collection (UB 1898 gf-2)

Signed (bl): *A. Henke*

Published by J. Hoover & Son, Philadelphia, 1899.

On the night of July 31st, 1898, the Spanish made a sharp attack at Malate with both infantry and
artillery on the American troops who were besieging Manila. For about an hour and one half both sides
kept up a heavy fire during which the American force sustained 10 killed and 33 wounded.

During the war and particularly in the months following the end of hostilities, several printmakers in America
produced souvenir prints hoping to cash in on the wave of patriotism. Joseph Hoover of Philadelphia was one of
the leading publishers of chromolithograph prints and had a reputation of catering to the tastes of the masses. It is
not known what the source of this picture was but the artist has managed to capture the confusion of a firefight.

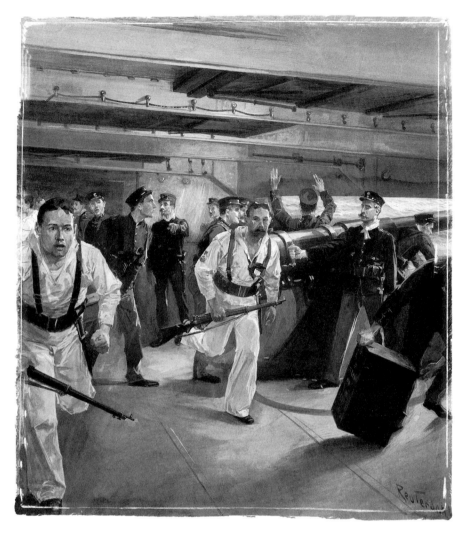

HENRY REUTERDAHL

"Cast Loose and Provide"
Action Exercise on board U.S.S. "Oregon," on the Voyage to Manila

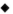

Oil "en grisaille"on illustration board 21 x 24 in. (53.3 x 61 cm.)
Jean S. and Frederic A. Sharf Collection

Signed and dated (br): Reuterdahl 98

Published in *Harper's Weekly*, December 24, 1898, cover.

The U.S.S. "Oregon" had participated in the battle of Santiago Bay, and then had returned to its base
in Callao, Peru, in order to be ready to proceed to the Philippines, if needed. Admiral Dewey had requested
this ship to strengthen his fire-power in the worsening situation in the Philippines, prior to the outbreak of the
Insurrection in February, 1899. The scene depicts an action exercise on the voyage to Callao; the "Oregon"
sailed from Callao for Manila on January 11, 1899. While Reuterdahl may have had descriptions and photographs,
it is more likely he used his imagination and extensive knowledge of naval ships, to construct this scene.

The artist had returned to New York in late June, 1898 due to fever but continued to serve
as a studio artist for *Harper's Weekly* and other publications. In August he covered the
victory celebrations in New York City, and later the Peace Jubilee in Chicago.

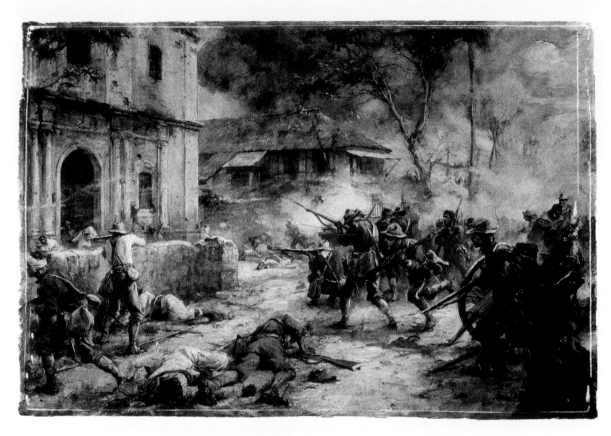

FREDERIC COFFEY YOHN

Attack on La Loma Church, Caloocan, February 10, 1899

◆

Oil painting on canvas 20 x 30 in. (50.8 x 76.2 cm.)
Society of Illustrators (Gift of the artist's brother)

Published in Frederick Funston, *Memories of Two Wars* (New York, Scribners 1914), page 203.
The caption reads 'I ordered the "Charge" blown, and all who could hear it sprang forward...
the whole regiment breaking into yells as we closed.'

During the Philippine Insurrection, the church at Caloocan, 12 miles north of Manila, was fortified by the
Insurgents. The attack on Friday, February 10, 1899 opened with a bombardment from the American fleet in
Manila Bay which started at 2:30 pm. At 4:00 pm the land attack commenced. American troops raced forward into
the town driving the Insurgents before them. Funston takes up the story: 'In no time we were over the trenches,
the survivors among the defenders bolting to the rear, the wall near the church being abandoned at the same
time. Some of them were shot down as they ran, but our men were so "winded" that their shooting was not as
good as it might have been.' The charge of the 20th Kansas Regiment under Frederick Funston was accompanied
by much cheering and the Insurgents were routed. By 5:30 pm the American flag was flying over Caloocan.

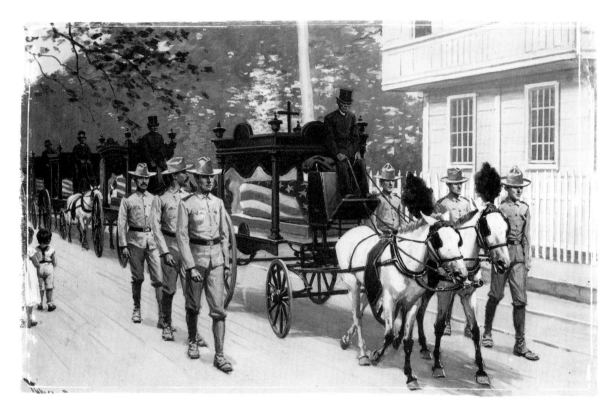

THURE DE THULSTRUP

A Soldiers' Funeral in the Philippines

Wash drawing on paper 18 1/4 x 28 3/4 in. (46.5 x 73 cm.)
Anne S. K. Brown Military Collection (U0 1900 gf-1)

Signed (bl): *Thulstrup*

Published in *Colliers Weekly*, February 3, 1900, pages 12-13.

In people's memory, the Spanish-American War involved the glorious sea battles and the charges up San Juan Heights. In the words of Secretary of State, John Hay, it had been a 'splendid little war.' Yet it lead directly into a vicious four-year struggle in the Philippines as the *insurrectos* under Aguinaldo sought to gain independence from America. The resulting casualties far outdistanced those suffered in Cuba, and both the Americans and Filipinos lost heavily.

This picture was drawn by Thulstrup in New York after a photograph by William Dinwiddie in the Philippines. An unusual practice in this case was that *Collier's* reproduced the photograph as an inset on Thulstrup's drawing. In August 1898, the paper had published another drawing this one by Gilbert Gaul, of a council of war before Santiago, based on a photograph which was reproduced inset. The Thulstrup picture was accompanied by the following quote: 'But woe unto that Man, and woe unto that Nation by whom the offence cometh' - Extract from Senator Hoar's article 'Shall we Retain the Philippines?' which was published on pages 3-5 of the paper.

Works In the Exhibition

◆

Carlton T. Chapman pg. 43
The "New York" firing on a Coast-Guard of Cavalry,
off Cabañas, Friday April 29, 1898
Gouache on paper 16 3/4 x 23 1/4 in. (42.5 x 59 cm.)
Jean S. and Frederic A. Sharf Collection

John Charlton pg. 71
(From a Drawing by Douglas Macpherson)
Santiago, Cuba: Hoisting the American Flag after the
Surrender of the town, 17th July 1898.
Col. Roosevelt's Rough Riders and Band in the Main Square
Wash drawing on paper 16 x 25 1/4 in. (40.5 x 64.2 cm.)
Anne S. K. Brown Military Collection (UO 1898 lf-1)

Howard Chandler Christy pg. 60
The Supreme Moment before Santiago
Watercolor on board 18 x 27 in. (45.7 x 68.6 cm.)
Jean S. and Frederic A. Sharf Collection

Stephen T. Dadd pg. 68
(From a Drawing by Douglas Macpherson)
Wounded Spanish Soldiers in the Church at Caney
Grisaille on paper 5 1/4 x 7 in. (13.3 x 17.8 cm.)
Jean S. and Frederic A. Sharf Collection

Charles John De Lacy pg. 46
The Spanish American War: Vessels of the United States North
Atlantic Squadron which bombarded San Juan, Capital of Porto
Rico, on May 12, under Command of Rear-Admiral Sampson
Grisaille on board 16 1/2 x 24 in. (42 x 61 cm.)
Jean S. and Frederic A. Sharf Collection

Amedée Forestier pg. 48
(From a Drawing by H. C. Seppings Wright)
The United States Camp at Tampa Harbour
Grisaille on paper 10 x 14 in. (25.4 x 35.4 cm.)
Jean S. and Frederic A. Sharf Collection

Amedée Forestier pg. 64
(From a Drawing by H. C. Seppings Wright)
Before the Battle of San Juan
Grisaille on paper 14 x 10 in. (35.4 x 25.4 cm.)
Jean S. and Frederic A. Sharf Collection

Amedée Forestier pg. 47
(From a Drawing by H. C. Seppings Wright)
The Harbour of Santiago De Cuba, showing Admiral Sampson's Fleet
Grisaille on paper 6 x 14 in. (15.3 x 35.6 cm.)
Jean S. and Frederic A. Sharf Collection

William Glackens pg. 51
The starting of General Shafter's Expedition to Santiago de Cuba:
American troops boarding transports at Port Tampa, June 7, 1898
Gouache 22 X 16 in. (40.6 x 55.9 cm.)
Jean S. and Frederic A. Sharf Collection

William Glackens pg. 62
The Twelfth and Twenty-Fifth Infantry taking the blockhouse at
El Caney, July 1st
Gouache 13 1/4 x 17 in. (33.7 x 43.2 cm.)
Jean S. and Frederic A. Sharf Collection

Albert Henke pg. 74
The battle of Malate, Philippines, night of July 31st 1898
[and inset portrait of Col. A. L. Hawkins]
Chromolithograph 20 x 28 in. (51 x 71 cm.)
Anne S. K. Brown Military Collection (UP 1898 gf-2)

Max F. Klepper pg. 49
Light-Artillery Drill of U. S. Regulars at Port Tampa, Florida -"Halt!"
Ink on paper 8 1/2 x 15 in. (21.6 x 38.1 cm.)
Jean S. and Frederic A. Sharf Collection

Kurz and Allison pg. 36
Destruction of the U.S. Battleship Maine in Havana Harbor,
February 15th, 1898, 9:40 pm
Chromolithograph 10 1/2 x 14 in. (26.7 x 35.5 cm.)
Jean S. and Frederic A. Sharf Collection

Kurz & Allison pg. 61
Battle of La Quasina near Santiago de Cuba, June 24, 1898
(Gen. Young Comg.) Rough Riders, 1st & 10th Reg. Cavalry
(About 1000) Routed 2000 Spaniards (who were in Ambush)
with heavy loss. AM: 18 Killed, 60 wounded, 9 missing.
Chromolithograph 20 x 28 in. (51 x 71 cm.)
Anne S. K. Brown Military Collection (UB 1898 gf-1)

Kurz & Allison pg. 59
Charge of the 24th and 25th Colored Infantry and Rescue of Rough
Riders at San Juan Hill, July 2nd, 1898
Chromolithograph 20 x 28 in. (51 x 71 cm.)
Anne S. K. Brown Military Collection (U1898)

Douglas Macpherson pg. 50
Waiting to Invade Cuba - Scenes at Tampa with the U.S. Army:
Waiting for the Guard Mount, 5th Infantry at Picnic Island
Ink drawing on paper 7 1/4 x 9 1/2 in. (18 x 24 cm.)
Anne S. K. Brown Military Collection (U0 1898 mf-1a)

Douglas Macpherson pg. 58
The bombardment of Santiago: Captain Capron's Battery in action
Ink drawing on paper 7 x 9 1/2 in. (18 x 24 cm.)
Anne S. K. Brown Military Collection (U0 1898 sf-1)

Douglas Macpherson pg. 72
Entry of General Shafter and his staff into Santiago, 17th July 1898
Ink drawing on paper 7 1/4 x 9 1/4 in. (18.2 x 23.7 cm.)
Anne S. K. Brown Military Collection (U0 1898 mf-1b)

Henry Marriott Paget pg. 69
(From a Drawing by Douglas Macpherson)
The Horrors of War: Feeding Starving Refugees from Santiago at
Caney
Grisaille 10 3/4 x 14 3/4 in. (27.3 x 37.5 cm.)
Jean S. and Frederic A. Sharf Collection

Fred Pansing pg. 70
The Nation's Welcome to the Victorious Fleet. The Fleet under
Admirals Sampson and Schley saluting Grant's Tomb, August 20
Oil on canvas 20 x 48 in. (50.8 x 121.9 cm.)
Museum of the City of New York

Charles Johnson Post pg. 52
Portrait of the artist in uniform
Watercolor on paper 9 1/2 x 6 1/2 in. (24.2 x 16.5 cm.)
Anne S. K. Brown Military Collection (Todd Collection)

Biographies

◆

Carlton Theodore Chapman (1860-1925) was born in New London, Ohio in 1860, and studied at the National Academy, the Art Students' League of New York and the Julien Academy in Paris. His speciality with marine subjects caught the attention of the illustrated press and he was hired as an illustrator. He died in 1925.

He was a Special Artist for *Harper's Weekly* during the war and travelled on the despatch-boat 'Kanapaha' with the North Atlantic Squadron out of Key West and on the blockade of the Cuban coast during April 1898. In addition to supplying drawings, Chapman also submitted accounts which were published in the weekly. After the fighting in Cuba ceased, he accompanied General Miles force during the campaign on Porto Rico as one of two artists representing *Harper's*, the other being T. Dart Walker, and covered the operations at Ponce in late July and August 1898.

John Charlton (1849-1917) was born in Bamburgh, Northumberland, England, on 28 June, 1849 and received his first art lessons at the age of four from his father. He then studied at the Newcastle School of Art; and finally at the South Kensington School of Art in London. In 1870, at the age of 21, Charlton had his first work accepted by the Royal Academy. He settled permanently in London in 1874, and began to work for *The Graphic* in 1876. His interest in military subjects grew out of his work for the weekly during the Egyptian war of 1882 when he depicted various aspects of the battle of Tel-el-Kebir. Later he exhibited a painting of the battle at the Royal Academy as well as other battle scenes, particularly focusing on horses in war. Queen Victoria commissioned Charlton to paint a scene of her 1897 Jubilee procession.

Howard Chandler Christy (1873-1952) was born in Morgan County, Ohio on January 10, 1873. He Worked for a number of new York illustrated which periodicals included *Leslie's* and *Century*, and when war broke out accompanied the 2nd United States regulars to Cuba on behalf of *Leslie's*. He witnessed the fighting at Santiago including Theodore Roosevelt's actions with the "Rough Riders", acquiring a reputation as a military artist. The artist was fond of telling anecdotes of his time in Cuba including one story relating to the planned attack at Las Guasimas. Before opening fire, the commanding officer turned to Christy and said: "If you like you may fire the first shot." He accepted the dangerous honor but after a time "began thinking of it that it might not be so fine after all. I was not an enlisted man, a soldier; I was an artist representing certain periodicals and in no way pledged to offer myself up as a target for Spanish rifles, although in the capacity of artist I was constantly under fire. No man voluntarily puts his life in jeopardy, so I decided that I didn't want to fire the first shot, and I didn't but the man who did was struck by a canon ball and his trunk and head blown away, the legs standing upright. They had to sweep him up for burial." In an article entitled 'An Artist at El Poso' published in *Scribner's Magazine* in September 1898, Christy vividly described the opening bombardment of the San Juan Block House on July 1st, and the carnage wrought by the opposing guns. He then witnessed Wheeler's brigade charging into the face of the Spanish Mauser rifles, and the charge up San Juan Hill. His sketches of the attack and the returning wounded dramatically captured the events for the readers back home. His pictures of the war also appeared in *Harper's*, *Truth*, and Wright's history of the war, and in the following year, *Scribner's* published

six of the figure studies depicting soldiers and sailors from the war. Later, he created many posters including a number during the Great War, and in later life he devoted his work to portraiture. He died in April 1952.

Stephen T. Dadd (fl. 1879-1914) came from a family of artists. He often collaborated with his well-known relative, Frank Dadd. He studied wood engraving with John Greenaway, father of the important artist, Kate Greenaway. Based in London, Dadd contributed genre and animal illustrations to numerous publications including *The Graphic, The Daily Graphic* and *Illustrated London News*, and he did numerous illustrations of the Boer War. His pictures were exhibited widely.

Charles John De Lacey (fl. 1885-after 1925), a native of Sunderland, England, served in the Royal Navy prior to attending art school at Lambeth, and South Kensington. He first exhibited at the Royal Academy in 1889. He worked as a staff artist for the *Illustrated London News* as their leading marine and naval artist between 1895 and 1900. He was their special artist with the Russian fleet in 1897. Later he worked for *The Graphic* and acted as special artist for the Admiralty and the Port of London.

Amedée Forestier (1854-1930) was born in Paris but came to London in 1882 to work as a staff artist for the *Illustrated London News*. He acted as a special artist regularly for the paper until 1899 covering royal occasions and ceremonies including the coronation of Nicholas II in 1896 and the Quebec Tercentenary in 1908. During the Spanish-American War, he was responsible for 'working up' many of the sketches dispatched from the front by Henry Charles Seppings Wright. In later life, Forestier became a noted illustrator of archaeological sites. Two of his works are in the Royal Collection at Windsor.

William J. Glackens (1870-1938) was born in Philadelphia in 1870 and studied at the Pennsylvania Academy of Fine Arts. At the same time, he did drawings for the local newspaper. After a visit to Paris, he returned to the States in 1895 and settled in New York where he found work with the New York *Herald* and the *Sunday World*. When war broke out in 1898 he was approached by *McClure's Magazine* and it was this publication which sent him to Tampato to cover the preparations. He worked with Stephen Bonsal in Tampa before they both embarked for Cuba in mid-June. The drawings that survive in the Library of Congress and elsewhere were worked up from quick pencil studies in his sketchbooks, two of which survive in the collection of the Museum of Art, Fort Lauderdale. His first illustration of the war actually appeared in *Munsey's Magazine* in June 1898, and began to show up in *McClure's* in October accompanying an article by Bonsal on the battle for Santiago and in December with another story by Bonsal dealing with San Juan Hill; while in 1899, his pictures illustrated war stories by Stephen Crane in the magazine. *Munsey's* also used his illustrations in a three-part article on the war which was published in the same year but many of his finer pictures of the war remained unpublished.

Albert Henke (1865-1936), born in New Jersey, eventually joined *Leslie's* as a special artist and spent much of 1898 covering events in Alaska. Little is known about the picture of the battle of Malate other than it was published by the important Philadelphia company of Hoover and Son which issued other war prints.

Sydney Higham (1890-1905) was noted for his comic artistry in black and white, but he was also an illustrator for several magazines and newspapers including *The Graphic* and *The Daily Graphic* for which he started to work for in the 1809's. In February 1896 he was sent to Las Palmas to cover the return of Dr. Jameson following the latter's failed rebellion in South Africa; in 1898 with war iminent with Spain and the United States, Higham was sent to Madrid early in April to cover the Spanish side of things, while Douglas Macpherson was sent to the United States. His first report from Madrid appeared in *The Daily Graphic* on April 29 and thereafter he sent numerous reports and illustrations back to London. During the Boer War he served as a staff artist in London, but in 1904 he was sent to Canada to report on immigration, and probably remained in that country for the rest of his life.

Max Klepper (1861-1907) moved to the United States from Germany in 1876, to Toledo, Ohio. Later he settled in New York where he worked as a staff artist for *Collier's Weekly*. His particular skill was drawing animals. Klepper sketched scenes at the New York State camp at Hempstead in April 1898 and worked in the city during the war re-drawing sketches sent from the front. Following the end of hostilities, he covered the returning soldiers at Camp Wikoff at Montauk Point, New York.

Kurz & Allison was one of the leading late nineteenth-century American publishers of chromolithographs. The Chicago-based company came to prominence nationally with a set of thirty-six Civil War battle scenes published in the 1880's from designs by Louis Kurz (1835-1921), himself a veteran of the war. Kurz, a native of Salzburg, Austria, had emigrated to the United States in 1848. Unfortunately Kurz and Allison's prints of the Civil and Spanish-American Wars are regarded as little more than naive fantasies of war and as such are dismissed by historians. Nonetheless, their pictures were a popular form of imagery and created images, albeit false images, of wars for thousands of viewers.

Douglas Macpherson (1871-1965) was born in Essex, England, on October 8, 1871, the son of the artist, John Macpherson with whom he received his early training. Macpherson moved to London to study at the Westminster School of Art, and was one of the original staff members of *The Daily Graphic* working with the paper and it's sister publication, *The Graphic* from 1890 until 1913. His service with the American Army in Tampa and Cuba was his first overseas assignment. He married in 1901 and had one son and three daughters. In 1902 he covered the Coronation of Edward VII, and in 1911, he covered the Coronation of George V. During the intervening years he had assignments in St. Petersburg and Madrid. Macpherson had an exceptionally long career. In 1913, he joined the staff of *The Sphere*, for whom he covered World War One and for whom he travelled to Egypt in 1923 to cover Howard Carter's discovery of Tutankhaman's tomb. During the 1930's he did free-lance work for various publications, and during the 1940's he covered World War Two for various publications.

Henry Marriott Paget (1856-1936) a native of Clerkenwell, England, entered the Royal Academy School in 1874, and by 1879, was exhibiting at the Royal Academy. His interest in depicting military events originated with his service in the 20th Middlesex Volunteers ('Artists' Rifles'), which he joined in 1875, serving with the unit until 1884. In addition to numerous illustrations of military events for *The Graphic* and *The Daily Graphic*, Paget was well known for illustrating adventure novels by Henry, Scott and Stevenson. Like so many artists of his generation, he was an especially prolific illustrator of the Boer War.

Fred Pansing (1854-1912) was born in Bremen, Germany but came to New York City with his family in 1865, and became a sailor by the age of 16. Following a short career at sea, he settled in New Jersey and began to paint maritime scenes and ship portraits many of which were published by Knapp & Co., and the American Lithographic Company. During the war, he was employed by *Truth* magazine along with Henry Reuterdahl and James G. Tyler, to cover the naval events, and one of his earliest pictures for the magazine depicted the North Atlantic Squadron leaving Key West for Havana.

Charles Johnson Post (1873-1956) studied at the Art Students League and first worked as a newspaper artist for the *Philadelphia Inquirer* and the New York *World* before joining New York *Journal* shortly after the "Maine" blew up in Havana Harbor. On the outbreak of war the 24-year old enlisted as a private in Company F of the Seventy-First New York Volunteers. He fought at San Juan Hill on July 1st where one-half of his squad became casualties. Following quarantine under suspicion of yellow fever, he spent three months in Roosevelt Hospital, New York City. During the campaign he made numerous on-the-spot sketches in two sketchbooks which were smuggled through the delousing station at Montauk Point. Later he used these along with memory to create a series of water colors and oil paintings, fifty of which are now in the Army Art Collection in Washington, D. C. Post wrote an account of his experiences in the war entitled *The Little War of Private Post* .

Frederic Remington (1861-1909) was regarded as the leading illustrator of the late 19th century in America, his reputation having been made in the west covering the campaigns against the native Americans. He had represented the New York *Journal* during the Cuban Revolution in 1896, so it was only natural that he would be asked by the *Journal* to work as their Special Artist; he was also employed by *Harper's* and *Collier's Weekly*, to provide pictures of the war, his first task being to cover the blockade of the Cuban coast where he spent a rather monotonous seven days aboard the U.S.S. "Iowa" 10 miles off Havana Harbor. He left the fleet and returned to the mainland where he covered the preparations at Tampa and Port Tampa. His pictures and accounts began to appear in May. Following the surrender of Santiago, Remington returned to the United States before heading off to cover the campaign in the Philippines.

Henry Reuterdahl (1871-1925), a native of Malmo, Sweden was commissioned to make sketches of the 1893 Chicago World's Fair, and decided to stay in America where he lived and worked until his death. He was primarily an artist and illustrator of naval and maritime scenes particularly of the Great White Fleet which circumnavigated the world in 1908. In the months prior to the outbreak of war, he covered the winter manoeuvers of the North Atlantic Fleet in the Gulf of Florida, and depicted the "Maine" in the days and weeks following the explosion. When war was declared he was sent into Cuban waters as naval war correspondent for *Truth* magazine. Unfortunately he came down with fever which forced him to return to Key West and he was back in New York City by the end of June 1898 just before Dewey's victory at Santiago. However he continued to produce illustrations of the naval war based on his earlier observations and accounts. Many of his illustrations along with his written accounts appeared in *Harper's Weekly, Harper's New Monthly Magazine, Century* and *Colliers*, and in *The Story of the Spanish-American War* published in 1900 by Peter Fenelon Collier.

Walter Russell (1871-1963) was born in Boston in 1871 and studied at the Museum of Fine Arts School before commencing his career as an illustrator with various New York illustrated magazines from 1890 until 1897. Later he turned to portrait

painting particularly children, including the children of President Roosevelt. With the outbreak of war with Spain he joined *Collier's Weekly* and traveled to Tampa where he sketched the arrival of Consul-General Fitzhugh Lee on April 11. A note in *Collier's* on April 16, 1898 states that 'Our Art Editor, Mr. Walter Russell, himself a well-known marine artist, is leaving for Key West to-night.' He also did work for *Century Magazine* and in the September 1898 issue, submitted an illustrated essay entitled 'An Artist with Admiral Sampson's Fleet' in which Russell described his experiences in the war. He embarked on the despatch-boat "Sommers N. Smith" from Key West on April 21 armed with "my half-packed luggage, three cameras, and nine half-gallon bottles of a popular spring water..." He recounted the hustle and bustle as the fleet prepared to sail, the watchword "Remember the Maine" scrawled in chalk everywhere on a warship, and the capture of the Spanish ship "Buena Ventura" by the "Nashville". Off Matanzas, he witnessed the first serious bombardment of the war and wrote of the monotony of a fleet on blockade before sailing up the coast to Cabañas where the ships watched and waited occasionally firing at any signs of life as Russell depicted in one scene.

William Small (1843-1929), a Scottish artist from Edinburgh, received his artistic training there before moving to London in 1865. While in Edinburgh, he had worked as an illustrator for a local publisher, where he was known as a quick worker and a prolific artist. He was thus immediately successful in London, commanding high prices for his work. He was one of the leading staff artists for *The Graphic* particularly specializing in the drawing of large double-page illustrations for which he was paid 60 guineas each, making him one of the highest paid illustrators of his time. His work was widely exhibited at all the major London galleries.

Walter Granville-Smith (1870-1938) was an artist and illustrator born in South Granville, New York. Regarded as one of the leading young illustrators in the late 1890's, Smith produced illustrations and magazine covers for *Truth, Ladies Home Journal*, and *Century Magazine*, as well as exhibiting at major exhibitions, including the National Academy of Design of which he became an Academician in 1915. It is not known where this group of Spanish-American War pictures were reproduced, though several may have been published in an illustrated history of the war.

Charles Joseph Staniland (1838-1916) came from Kingston-upon-Hull, England, and studied at the Birmingham School of Art and at the Royal Academy Schools. He worked as a staff artist for the *Illustrated London News* in the 1870's and for *The Graphic* from 1880 until the turn of the century. He was noted for his excellent marine and naval scenes, and for his portraits, and was much admired by Van Gogh during the latter's English years. Staniland was elected to membership of the Royal Institute of Painters in Watercolours in 1879, and to the Royal Institute of Oil Painters in 1883, and his pictures were exhibited widely.

Thure de Thulstrup (1848-1930) was one of the leading illustrators of military subjects in America at the turn of the century. Like Reuterdahl, he was born in Sweden but moved to the United States in the 1870's settling in New York City in 1876. He worked for various newspapers and was a prolific illustrator for books and journals. In 1881 Thulstrup joined Harper and Brothers and was one of their principal staff artists throughout the period of the Cuban Insurrection and the Spanish-American War. He also did work during the war for *Collier's Weekly*. Thulstrup's pictures of the war appeared also in *Lest We Forget* (1898), *Harper's Pictorial History of the War with Spain* (1898), *The Story of the Spanish-American War and the Revolt in the Philippines*, and *The War with Spain* by Henry Cabot Lodge (1899).

David B. Waters (fl. 1887-1910) a marine painter and illustrator, active in Edinburgh and London from 1887 until 1910. His work was exhibited at the Royal Academy; and his illustration art was published by *The Graphic* from 1898 until 1910. His last known assignment for *The Graphic* was as a Special Artist at the 1910 Fleet Manoevres.

Henry Charles Seppings Wright (1850-1937) studied in Paris and served for a short while in the Royal Navy before turning to pictorial journalism. After working for *The Pictorial World* in 1883, he joined the *Illustrated London News* around 1888. He served as the paper's special artist during the campaigns in Ashanti, the Greek-Turkish war, and Sudan. Later he was the special in the Russo-Japanese War and the Russian front in 1915-1916. During the Spanish-American War he observed the camps at Tampa and the fighting on Cuba and had actually made a landing on the island as early as May before the expeditionary force had landed. As the *Daily Chronicle* described the incident on May 11, 'Mr. Seppings Wright, Special War Correspondent and Artist of the *Illustrated London News*, and Mr. Scovel landed in Cuba a week ago to send forward a dispatch from Admiral Sampson to General Gomez to inquire what arrangements he is making for cooperation with American troops, and to arrange a place of meeting...' When the expeditionary force landed in June, Wright accompanied the artillery and during the fighting at El Pozo on July 1, he was seen along with two New York *Herald* correspondents, resting their portfolios on the wheel of a gun in Grimes' battery even though the gun was firing every five seconds. 'While the Mausers sizzled and the shrapnel burst these men were snapping cameras and working pencils with the nonchalance of their studio hours and with far more enthusiasm.'

Frederic Coffey Yohn (1873-1933), a native of Indianapolis, studied at the Art Students' League in New York and opened a studio there in 1895. He began illustrating books and magazine articles particularly for Scribners and he was to maintain a long connection with this company. During the Great War he designed posters and painted several important scenes including official paintings. He died at Norwalk, Connecticut. Yohn was one of *Collier's* main staff-artists during the war of '98 based in New York City, although in April and May 1898 he covered the camps at Chattanooga and Chickamauga. He illustrated Frederick Funston's account of the Spanish and Philippine campaigns, *Memories of Two Wars* published by Scribners in 1911.

Rufus Fairchild Zogbaum (1849-1925) was a native of Charleston, South Carolina, but moved to New York around the time of the Civil War. Later he studied in Germany and France before returning to New York to begin a career as an illustrator particularly of military and naval scenes. He worked for *Harper's* during the war against Spain and accompanied the fleet in the operations along the Cuban coast. He was one of the few correspondents to witness the bombardment of Matanzas, and his account of this action was published in the weekly on May 21. Similarly, he was one of only half a dozen journalists to accompany the mission of the "Gussie" whose task it was to unload weapons and equipment to aid the Cuban insurgents. More significantly, Zogbaum was one of only a handful of artists and correspondents allowed to travel on board Admiral Sampson's flagship, the "New York", during the opening operations, a privilege possibly due to his longtime connection with the navy and the various books and articles he produced on the subject including his 1898 pre-war book, *All Hands*.

◆